CREATIVE FASHION DRAWING

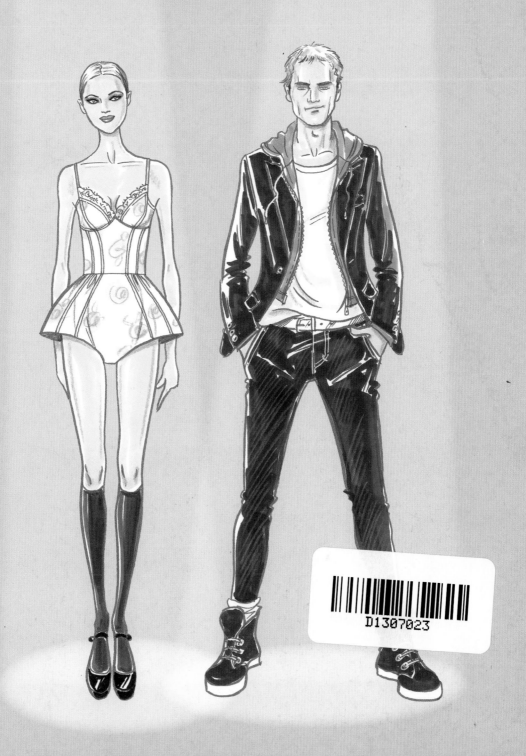

CREATIVE FASHION DRAWING

A COMPLETE GUIDE TO DESIGN AND ILLUSTRATION STYLES

NOEL CHAPMAN AND JUDITH CHEEK

ARCTURUS

Noel Chapman trained in fashion and textiles design. He is a consultant designer specializing in womenswear, knitwear, market and creative intelligence, who works with a wide range of clients throughout Europe, the USA and the Far East. Noel also writes on fashion-related subjects and lectures in fashion, textiles and knitwear design. www.noelchapman.com

Judith Cheek trained in fashion design at St Martins School of Art before specializing in illustration. She works with a wide range of clients across all levels of the industry and her illustration work covers fashion, beauty, health and exercise, cookery and food. www.judithcheek.co.uk

We would like to thank everyone who has so generously given their time and their work to this book, and to say a special thanks to Yvonne Deacon for her huge contribution and for freely sharing her thoughts and ideas. Without everyone's generosity this book would never have happened. Sadly, Elizabeth Suter died before the book was finalized. Her drawings are a most valued and stylish contribution – thank you, Elizabeth.

Unless otherwise credited, all drawings and illustrations in this book are by Judith Cheek.

Cover credits Front cover, left: Judith Cheek; right: Getty Images/Lauren Bishop. Back cover, left: Yvonne Deacon; all other illustrations: Judith Cheek.

This edition published in 2012 by Arcturus Publishing Limited 26/27 Bickels Yard, 151–153 Bermondsey Street, London SE1 3HA

ISBN: 978-1-84858-469-3
AD002037EN

Printed in Singapore

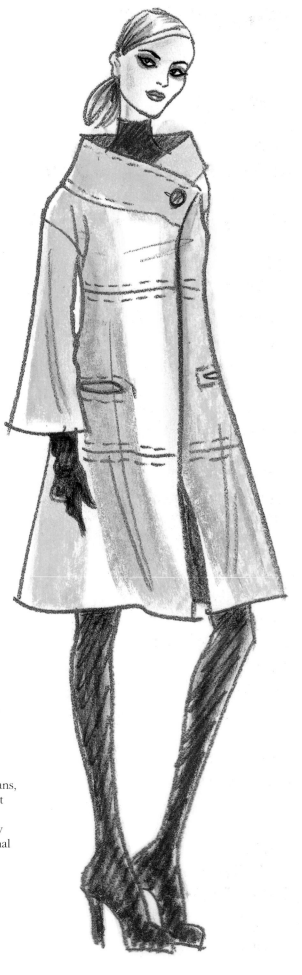

CONTENTS

INTRODUCTION

This book is aimed both at designers who want to brush up their fashion drawing and illustration skills, and at would-be designers who want to learn how to draw and illustrate fashion from scratch. It is about learning how to draw fashion ideas better – how to record and develop your ideas, whether for your own enjoyment and purposes, or in order to help you on your way towards a career in the industry, where being able to draw and record fashion is a real advantage.

What does the design process involve? What do we mean by inspiration and research and which comes first? And how do drawing and illustration fit into this puzzle? These are some of the questions this book aims to answer as it charts the processes and activities of fashion drawing and designing.

Whatever the particular discipline of the designer and, arguably, of the artist too, the need to draw reasonably well is paramount, despite the popular if naïve opinion to the contrary. However, what qualifies as a drawing, and particularly a fashion drawing, depends very much on the individual and whether or not the drawing is 'fit for purpose'. It is at this point that we may meet with some confusion: what is the difference between fashion drawing and fashion illustration? To put it simply, fashion drawing is what designers do first to record and develop their design ideas, and secondly to convey those ideas to others, for example to the machinists and factory workers who will be making the garments. A fashion illustration is often commissioned by a fashion designer, a magazine, or perhaps by a PR team to convey the ideas of the designer. It may be intended to articulate something bigger than simply the clothes – the concept of the collection, or more generally the idea or desired image of the designer's brand. This idea or image may encompass all kinds of intangibles: it could for example be the task of the artist to express an attitude, or a perfume, and so while the illustration may break many of the rules of fashion drawing per se, it provides a medium through which a designer may express their ideas. Regardless of the reasoning behind the fashion drawing or fashion illustration, the result needs to fulfil its aim: to be 'fit for purpose'.

Let us start by considering fashion drawing, which is the art of rendering the human figure, clothes and accessories in an attractive and comprehensible manner. To understand the processes and reasoning behind drawing fashion, it is important to appreciate the stages that a designer may go through in the course of the creative journey. The designer may have an idea, and will need to record that idea – to draw it effectively and commit it to paper before it gets away. That idea then needs to be developed and refined, which usually involves a process of redrawing, of questioning and evaluation. Does the image depict what I was thinking about/trying to express? Are the proportions good? Is the silhouette right? Are the details correct and in the right place? Does the colour balance work? The cutting and construction of the garment are also part of the design ethos and require due consideration and attention. These are just a few of the many judgements that need to be made, all of which will contribute to the successful realization of the design. Both the idea and the final outcome may evolve dramatically from the first sketches, and the processes of drawing and design are inextricably entwined.

Neil Greer
This digitally produced artwork was hand-drawn using a pen and tablet and the computer programme Painter.

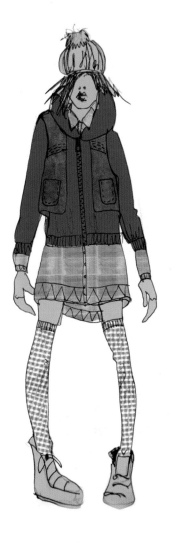

Rosalyn Kennedy
Client: *Bruce Oldfield*
Brush pen and pastel on coloured Ingres paper.

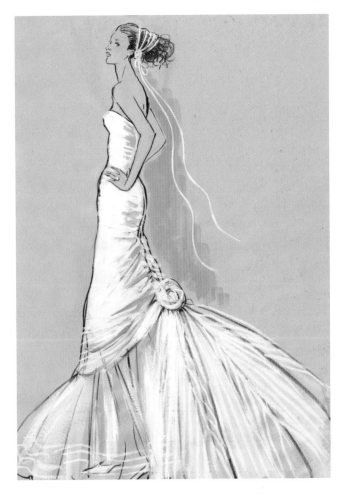

Katharina Gulde
Client: *ONLY Bestseller*
Hand and digital drawing combined.

This book will guide you through a series of tutorials and aims to help you create better, more professional drawings. It will also endeavour to encourage your own personality to shine through by showing you different possibilities across a range of media, techniques and styles.

We shall talk about equipment and materials, from the most elementary to a range of more specialist and experimental media, including a little about computer drawings and their use – but first you need to be able to draw by hand. In order to do this we reveal how to draw a model: the human figure – static, posed and in movement – that will later be dressed. This is always the starting point and we shall examine in detail how to accurately depict proportions and details such as hands, feet, heads, hair and faces. It is important to point out at this stage that choosing the styling and look of a drawn figure is just like selecting a live model for real garments; the look and attitude have got to be right for overall success – the wrong model with the wrong hair and look won't wear the designs well.

Next, we shall look at how to draw different fabrics, focusing on their surfaces and qualities, such as whether they are tweedy and chunky or fluid and floaty and so forth. It is then possible to plot the designs of the clothes on the figure, getting the silhouette, fit and proportions correct before moving on to the finer points, such as styling and construction lines, and how to draw pockets, collars, stitching and other details.

Once the design has been refined, the drawing as an artwork needs to be completed with the addition of colour, texture and pattern. We also reveal how to draw 'flats' – the technical or specification drawings necessary for manufacturing – that show clearly and precisely the garment's proportions and construction, the positioning of details and so on. These are drawn off the body, as if the real garments were lying flat on a tabletop. We also cover how to draw accessories, with ideas and techniques to help you depict your ideas clearly.

Lastly, the final chapter shows a wide variety of contemporary fashion drawings and illustrations by an international range of designers and artists. This is intended to both inspire you and demonstrate the fabulous range of possible styles, all of which are in their own way fit for purpose.

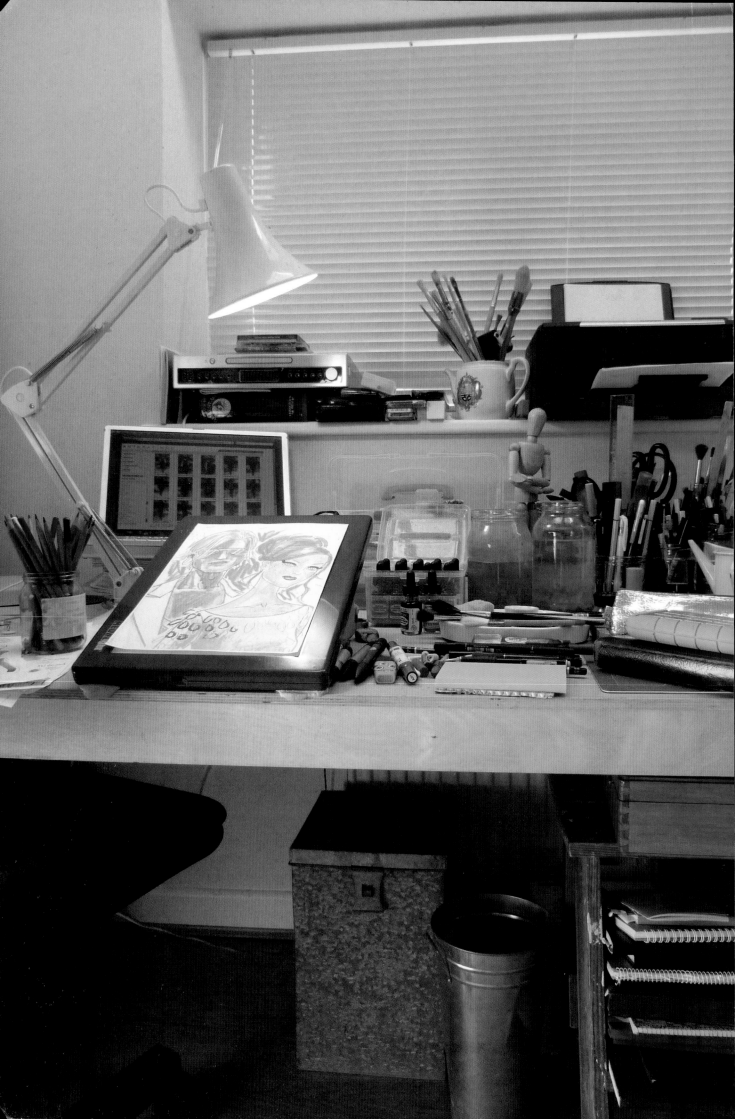

CHAPTER 1

EQUIPMENT AND MATERIALS

Ask any designer what materials and equipment they need to draw and design and you will get a range of different answers. However, many will suggest that you start with a few simple pencils and some ordinary paper. This is fine initially but, as any designer will soon confirm, you will soon begin to favour certain types and brands, both for the way they perform and the marks they make and also how they feel in your hand. The size and shape of your hand, the speed and size at which you draw, and how hard you press all have an influence on your choice of implement, and this is before we even begin to consider the effect you wish to achieve in the actual drawing. Similarly, designers often prefer particular sketchbooks, whether they are large or small, landscape or portrait, spiral-bound or sewn, or zigzag or concertina types. This section aims to reveal the choices on offer and the attributes and benefits of the different types.

YOUR WORKSPACE

While a sketchbook is something you probably use anywhere, including out and about, it is also a good idea to have a dedicated work area – somewhere organized to suit your needs and promote efficiency. It should also have a good natural light source, if possible by a window, and ideally have a movable work lamp fitted with a daylight bulb (full spectrum light) for more accurate colour work. This space should offer you a place in which you can concentrate, where you have everything you need to hand, and where you can safely leave projects out without them being disturbed.

A desk or table that is steady and a comfortable chair with good back support are very important. Many designers like to draw on an angled surface. This does not need to be a sophisticated system – it could simply be a drawing board propped up at the back on a block or a small pile of books or magazines. A wooden A2 drawing board is generally best as it is manageable but has a sufficiently large surface area. The minimum size is A3.

BASIC EQUIPMENT AND MATERIALS

While a designer may be perfectly happy with little more than an average pen or pencil and a stack of bulk paper, that is rarely enough for a good illustrator, who will usually carry a range of lead and coloured pencils, various pens, lots of types of paper and several adhesives. All the following usage descriptions are based on manufacturers' guidelines, but you can and should experiment, mixing as many together as you like.

HOLDING A PEN OR PENCIL

Before we look at the different types of materials, it is vital that a distinction is made between the right and wrong ways to hold a pencil or pen. It may sound dogmatic, but thousands of years of experience have shown that holding a drawing implement in a certain way does produce better results, so it is worth persevering to correct your technique and, if necessary, relearn altogether.

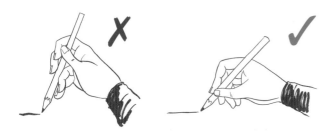

BASIC EQUIPMENT

- Pencils are graded from hard to soft, with H being hard and B soft. Both types are graded by number, with the highest being the hardest and the lowest the softest in the H range and vice versa in the B range. Choose a few different types and experiment. Automatic and clutch pencils, which contain an internal lead core that can be wound up and down, are also available with different grades of lead. These are very useful for getting ideas down quickly and cleanly, as well as being easy to use and maintain as you don't need a pencil sharpener. They are a little more expensive than standard pencils but are invaluable when you are out and about.
- Coloured pencil crayons come in a good selection of hues, and are either plain or water-soluble, with the latter giving a softer, more smudgy effect. As

with anything, the quality varies and you get what you pay for, but a good start would be a basic selection box or carton of around 20 or so colours that you can add to as required. You need to look after pencil crayons – try not to drop them or shake them about too much as the leads will break inside. If you plan to carry them about with you, keep them in the box they came in or in a snug-fitting container.

- Ballpoint and rollerball pens are available in an ever-greater range, including those with gel inks, which are easy to obtain and use. As with all drawing implements, choose ones that are comfortable to hold and work with. It is worth trying out a few in an art store before purchasing one.
- Fine fibre-tipped or fine-liner pens range from the finest 0.05 mm nib to a thick 0.8 mm nib and are great for drawing technical 'flats' as well as for general drawing. The variety is huge, and your decision will be based on the effect you are hoping to achieve. Some give a very clean graphic look while others are more fluid, and different brands can vary too. They are either water- or spirit-based.
- Brush pens enable an illustrator to create very fluid lines in a variety of thicknesses, giving the swift, deft, expressive line you get from a paintbrush, but with the cleanness and convenience of a fibre-tipped pen. Both brush and fibre-tipped pens are useful for adding texture to fashion drawings when trying to depict different fabrics.
- A stapler and adhesives such as masking tape, clear tape and double-sided tape are required for masking areas of drawings, joining and fixing layers and combining materials.
- Stick glue is useful for adding elements such as scraps of materials and so on to sketchbooks.
- Bulk paper is available cheaply in different qualities, mostly graded according to weight. A4 size at 80 gsm (grams per square metre) or 90 gsm is a good basic paper. Sketchbooks vary according to paper quality and size; a standard A4-size sketchbook of cartridge paper will generally suffice, although those who prefer more space should go for A3. An A5 pad is a must for your pocket when travelling about. For more about paper see page 14.

Hard pencil

Medium pencil

Soft pencil

Coloured pencil crayons

Ballpoint pen

0.05 mm
fine fibre-tipped pen

0.5 mm
medium fibre-tipped pen

0.8 mm
thick fibre-tipped pen

Brush pen

Water-based thick
fibre-tipped pen

Coloured fibre-tipped pen

Spirit-based thick
fibre-tipped pen in
different colours

BUILDING UP YOUR KIT: EXPERIMENTAL AND SPECIALIST

Once you have got the hang of some basic skills and are more confident you can build your range of techniques by experimenting with a broader spectrum of specialist implements. These are termed 'dry' or 'wet'. In addition there are numerous types of paper that can be explored, producing a range of different finishes.

DRY MATERIALS

- Graphite pencils come in a huge range, from hard leads that give a very fine, faint line, to dark and soft leads that can be smudged with a finger and produce a rougher, more fluid line.
- Chinagraph pencils are waxy and make a bold mark on any surface.
- Conté pencils are very hard pastel crayons with which a variety of effects can be achieved, from very soft to dark and smudgy marks.
- Charcoal pencils are essentially charcoal in a pencil form, which means that they are not as messy to use as lump charcoal. Various grades of charcoal can be bought in this form. It is very fluid, and an extreme variety of lines and marks can be achieved – from the very soft and subtle to dark and bold scribbles – all of which can be easily smudged.
- Chalk pastels are either soft or hard. Pigment is bound together with clay and gum arabic and, as with paints, their price reflects the amount of pure pigment they contain. The first three saturations, containing the most pigment, are the most expensive, and as more white is added to make them paler, so the price reduces. Since they are expensive it is worth trying out just one or two to see if it is a medium you want to use. Soft and subtle effects can be achieved by overlaying, smudging and blending colours.

- Oil pastels comprise pigment bound together with beeswax or mineral wax and non-drying petroleum jelly. They are very waxy and produce a bold, textured line that is excellent for quick life studies. Another feature of these pastels is they can be used to block in large areas of colour and then blended to a flatter colour using lighter fuel, white spirit or turpentine.

WET MATERIALS

- Marker pens are spirit-based and are available in a fantastic range of colours. Each pen usually has two different-sized nibs, making them a versatile, clean and quick way of putting down flat colour.
- Watercolours are blocks of pigment bound together with gum arabic, glycerine, resin and sugar. Water is applied with a brush and the paint can then be transferred to paper to give bold washes of colour, or to build up layers of colour in a tonal way. Once dry, subsequent layers of colour can be added on top.
- Coloured and black inks are essentially concentrated watercolours, and are used in much the same way. They produce very intense colours, which is especially useful if illustrations are going to be reproduced. They can be applied with a brush to create washes of colour or with a pen to produce a lively, scratchy line or to add finer details.
- Gouache, generally called designers' gouache, is an opaque water-based paint that is used for laying down flat colour.
- Fixative spray is used for fixing pencil, crayon, charcoal and pastel once an illustration is complete.
- Spray Mount adhesive is essential for mounting work flat. Make sure you use it in a well-ventilated room to avoid a build-up of fumes.

DRY MATERIALS

Graphite

Chinagraph pencil

Conté pencil

Charcoal pencil

*Chalk pastel blended
with finger*

*Oil-based pastel blended
with white spirit*

WET MATERIALS

Nib pen and ink

*Marker pen
using a broad nib*

*Marker pen
using a fine nib*

*Watercolour over
masking fluid*

*Concentrated pigment
drawing ink over wax
crayon (wax resist)*

Gouache

PAPER

• Basic bulk paper is invaluable for working out ideas in rough. Printer paper is normally available in A4 and A3 sizes and often has a weight around 80 gsm. The most economical way of buying it is in reams (packs of 500 sheets) from office suppliers.

• Layout paper is thinner than printer paper – about 45–55 gsm – and is semi-transparent. You can work through a series of roughs, amending an image by putting another sheet over the top and redrawing and adjusting it until you get your 'finished rough'. The easiest way to do this is to buy the paper as a pad and begin at the back, working towards the front. Spirit-based pens and fibre-tipped pens will bleed through to the sheet underneath, so be aware of this. Many designers insert a sheet of heavier paper beneath their drawing page for protection.

	Medium pencil	Soft pencil	Charcoal	Nib pen and ink	0.8 mm fibre-tipped pen	Brush pen	Ballpoint pen
Bulk paper							
Cartridge paper							
Bleedproof paper							
Watercolour paper (NOT)							
Ingres pastel paper							

- Cartridge paper is heavier and better quality than printer or layout paper and can be used with various mediums. It is an economical choice if you want to experiment with ways of putting down colour. It is available in sketchbook form in many sizes, and as separate sheets.
- Bleedproof paper (around 70 gsm) is for use with spirit-based pens (marker pens) and enables you to lay down flat colour with a clean edge. Although

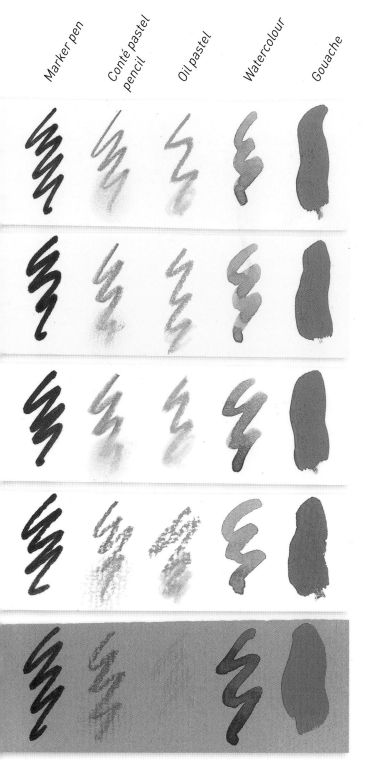

you can use marker pens on any paper, they can appear dark and streaky, giving a soft, blurred edge, so bleedproof paper is the best choice if you want a crisp, reliable result. Alternatives include the heavier-weight Paris bleedproof paper, and Bristol board – a smooth, double-faced paper of about 250 gsm that can be used on either side. It is best to use heavier-weight paper if the finished drawing is for your portfolio as thinner types start to look shabby quite quickly. Thinner ones are fine for artwork that is going to print.

- Watercolour paper is generally used with watercolour paints and coloured inks. It is available in three forms: 'cold press' (called NOT), which has a rough-textured surface and is good for transparent washes and inks; a still rougher version (called ROUGH); and 'hot press' (HP), which has a smoother finish and is better for use with opaque paints such as gouache. All watercolour paper comes in various textures and weights starting at around 160 gsm. Experiment to find the ones you like.
- Ingres paper is designed for pastel work, gouache or collage. It is a beautiful, textured laid paper that takes its name from the neoclassical French painter who favoured it.
- In addition to paper that you can buy, you can use scraps of paper torn from magazines or start a collection of textured and coloured papers for collage work or more experimental drawings.

ADDITIONAL EQUIPMENT

- Lightboxes are useful but not always essential if you prefer to work directly on to your drawing paper. If, however, you want to draw a rough first, you can then attach it to a lightbox, place a fresh sheet of paper over the top and trace the rough. You can easily see if this method works for you by attaching a rough drawing to a brightly lit window with masking tape, then placing another piece of paper over this and tracing the image.
- A computer, printer and scanner, while not essential, do provide extra scope and can be beneficial. There are many ways to enhance hand-drawn images, such as adding colour and texture, changing the scale of a scanned drawing, combining multiple drawings, or creating collages by inserting photographs, images and text. However, you should always bear in mind that: '... *these methods do not improve creativity and should only be used as tools to extend ideas...*' (Patrick Morgan).

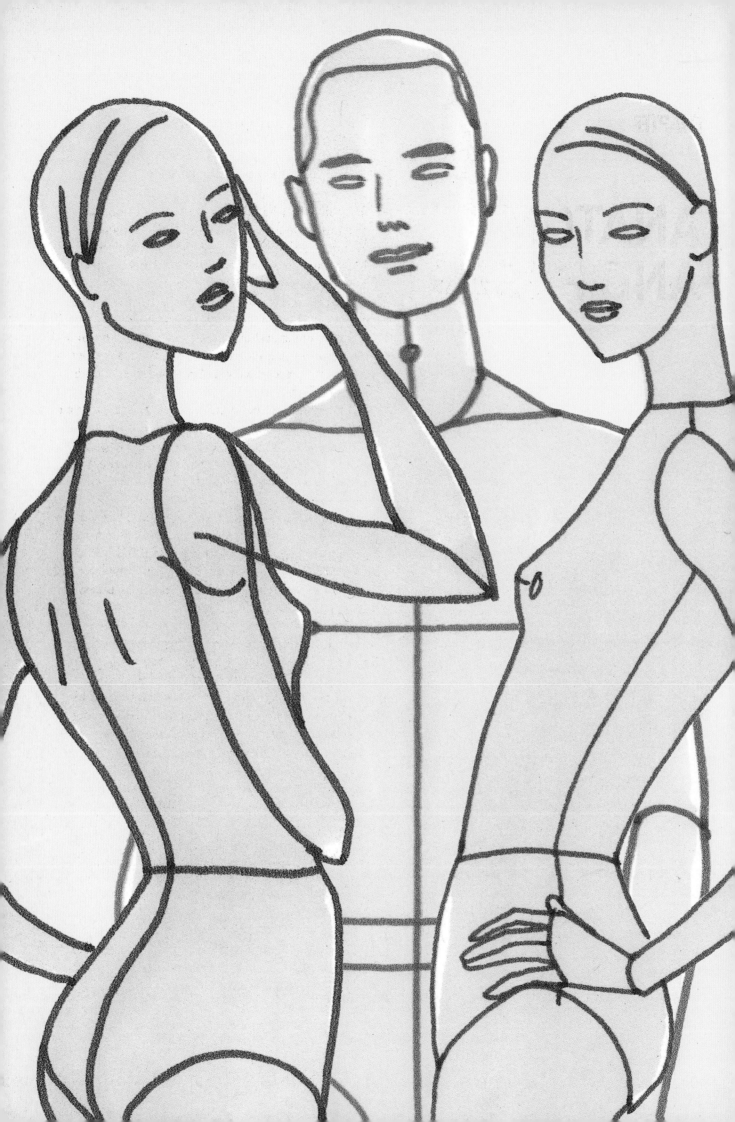

CHAPTER 2

ANATOMY AND POSES

The first step when drawing fashion is to develop a figure – a model that will wear your designs. You may end up with a range of characters that is constantly evolving, but when starting out it is best to perfect one quite basic form that you can adapt to suit different purposes. In this section we shall examine in detail how to get the proportions right for males and females of all ages; how to draw different poses, both static and dynamic; and how to accurately depict details such as hands, feet, heads, hair and faces.

Once you have perfected these skills and achieved a physiologically accurate figure, it is important to allow your individual style to develop, and this chapter contains a wide range of different examples across a mix of mediums and styles that should provide inspiration. It is easy to personalize the figure by varying the skin tone, hair, make-up and so on, and you should try out lots of options. Choosing the styling and look of your drawn figure is just like choosing a live model for real garments; the look and attitude has got to be right for the overall success of the illustration.

Once perfected, this template can be placed underneath a drawing sheet and you can loosely trace the shape of the figure. In addition, you can reduce or enlarge the size of the figure on a photocopier or computer so that it can be used for drawings of almost any scale, as well as replicating numerous forms that can be used to depict a fashion collection.

PROPORTIONS OF THE FASHION FIGURE

All fashion artists apply a certain amount of creative licence to the proportions of a drawn figure – some more so than others. This is because elongating a figure enhances the appeal of the design. The extent of the exaggeration can depend of the final outcome and purpose of the piece, but a fairly standard female fashion figure is seven and a half to eight and a half heads tall, and a male form is around nine heads tall.

It helps when drawing a figure to think of it as a human body, envisaging the skeleton that supports it, the organs it encases and protects, how and where it bends and twists, the joints and muscles that enable those movements, and the distribution of weight and how that shifts as the body moves. It is equally beneficial to consider the physical space that the body occupies, and how perspective affects our view of that space. Taking life-drawing classes can be hugely advantageous as it will expand your knowledge and experience of drawing the human form and probably enable you to try out a range of media too. As with anything, practice makes perfect.

These sketches show a simple static pose and demonstrate how a stylish figure can be drafted using heads as a measurement guide.

Note the characteristic differences that define a male and female form: the female figure has narrower, sloping shoulders, a smaller waist and larger hips (approximately the same as the shoulder width) than the male. Her bust is rounder and placed about midway above the waistline, while the neck and limbs are slimmer and less muscular. The male figure, on the other hand, has shoulders that are wider than his hips, a thicker and perhaps shorter neck, and his

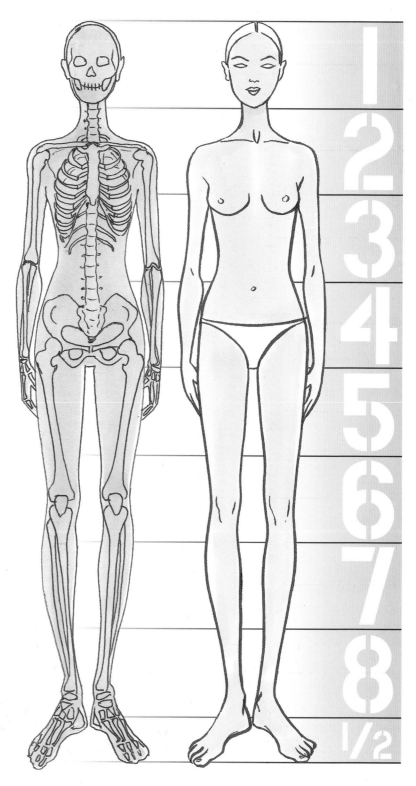

body is proportionately a little longer, which results in a lower waistline and a more square-shaped chest that sits a little higher than midway above the waist. The limbs are heavier and generally a little more muscular and larger feet plant him more firmly on the ground. Many designers and illustrators often initially struggle to draw male figures that look convincing yet stylish, but with practice this can be mastered.

This straight-on pose is the simplest to draw, and allows numerous easy options for arm positions. It is clear and simple to 'dress' in garments.

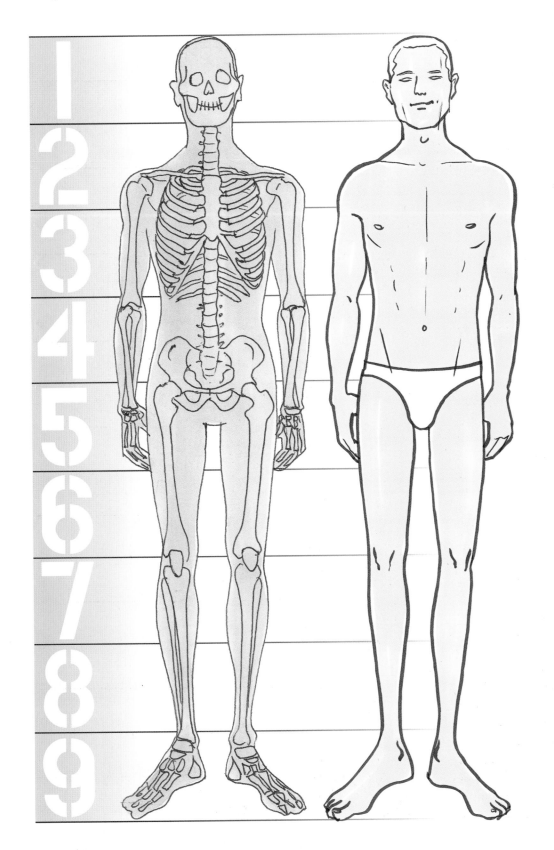

DIFFERENT AGES

Here we depict a whole family of figures, each with their own characteristics which must be taken into consideration when drawing in order to depict proportions accurately.

The fact that children have very different growth rates makes it difficult to create a definitive proportion template for each age group. As any parent knows, the size of garments for a specific age range can vary tremendously from brand to brand. If you ever have to design or draw for a childrenswear company they should supply their own size charts. There are, however, some general guidelines:

• A baby's head makes up about one-quarter of the total body length. By the age of one, the head is about two-thirds the size it will be when fully grown, so most of the growth thereafter will be seen in the body and limbs. Babies have short, almost invisible (from an artist's perspective) necks and large round torsos. Their small, chubby limbs are bent rather than straight.

• Toddlers usually have a body that is about four and a half heads high. The shoulders are about the same width as the head height, and they have quite cylindrical bodies, sometimes with quite round tummies. Poses should be fairly static for a toddler, as they are just learning to stand and walk, so the feet are firmly planted on the ground.

• Small children are about five heads tall. Since these lively little people rarely keep still they can be depicted in more active poses.

• Bigger children range in height from six to six and a half heads, although by this age boys and girls can have very different heights. They still have cylindrical torsos and a very straight up-and-down silhouette, although older girls, from about the age of nine or ten, may start to have a slight indentation at the waistline, which is higher than a boy's. Older boys have longer torsos, slimmer hips and slightly wider shoulders than girls.

• By the teenage years (sometimes called Junior in stores), children's height can be seven or eight heads. As hormonal changes take place, male and female forms become more pronounced, and the proportions of the teenage body are quite different from a younger child's. Boys have

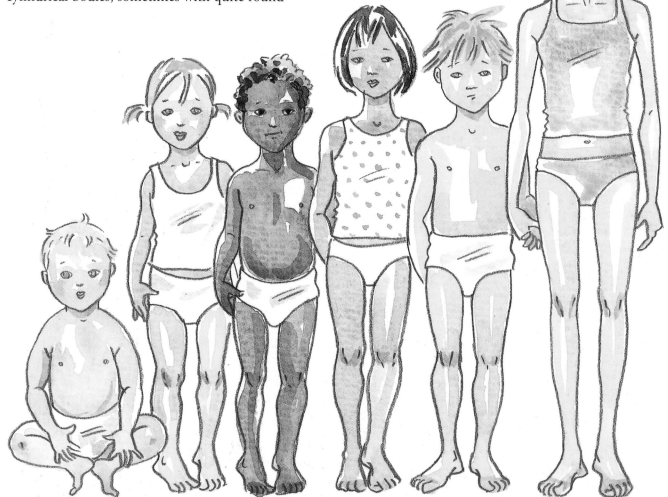

lower, slimmer hips and much longer torsos, which makes the arms and legs appear shorter. The differences are also apparent in head sizes, with girls having smaller heads and more petite facial features, which in boys tend to become more angular. As the body mass increases with age, the difference in muscularity between the genders becomes more apparent.

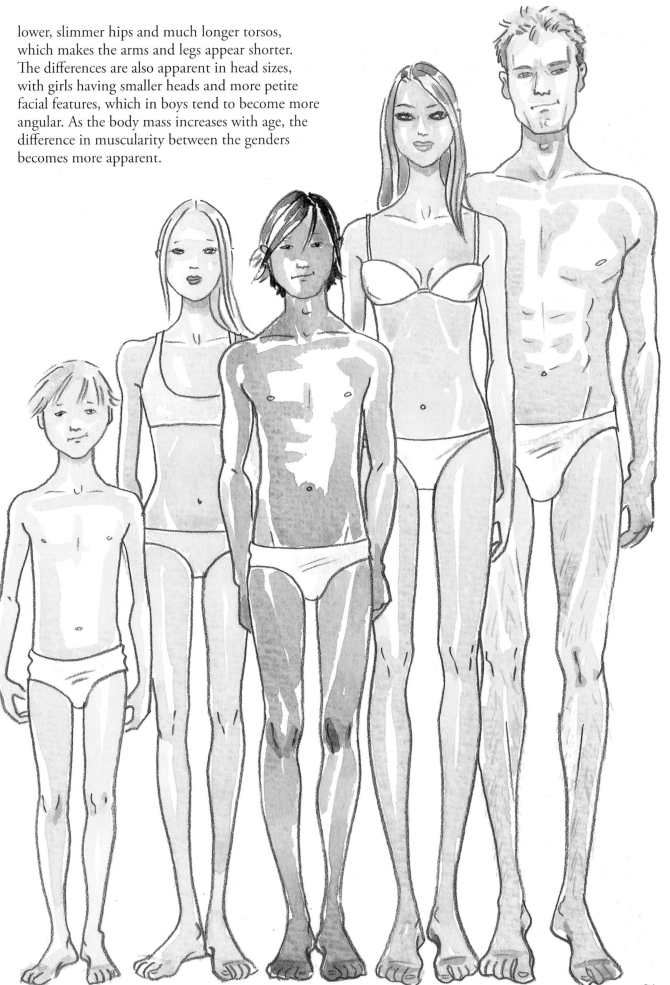

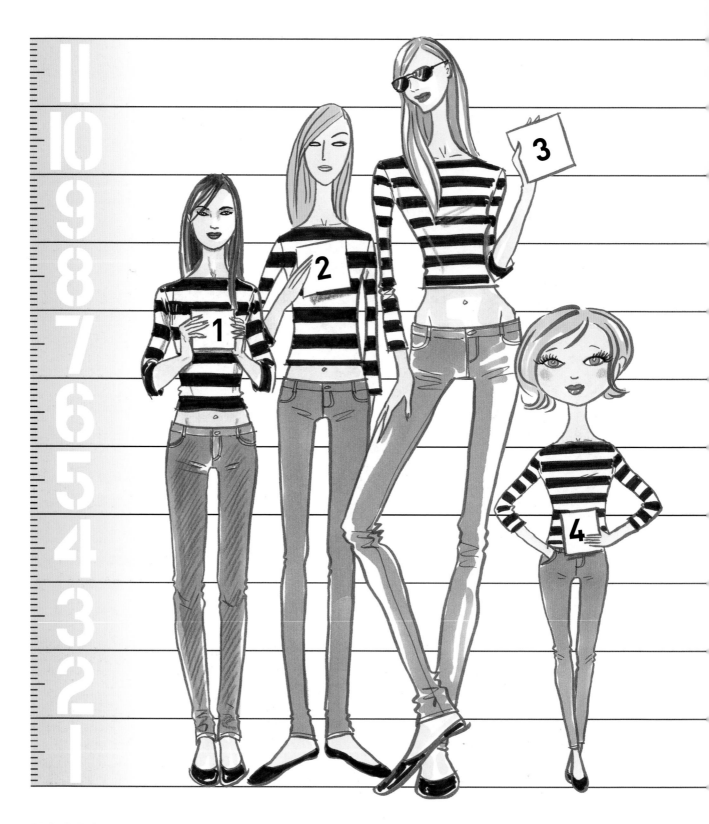

PROPORTION AND CHARACTER

As we have seen, a body height of around seven and a half to eight and a half heads is used for a stylish but not over-stylized female figure, and is pretty much an industry standard. However, having adhered to this basic guide, you can now add individuality and personality with facial features, make-up and hair styling. In addition, when the project allows more scope, you can have some fun with proportions. Large heads can lend a character a funky alien quality or be naïve and endearing. Similarly, heads that are too small can be comic and engaging, or perhaps slightly insect-like or even sinister! Over-elongated and attenuated figures are very striking – think of the sculptures of Alberto Giacometti, which are on the one hand tall and shadowy yet on the other amazingly stylish and elegant. Exaggerated large feet that plant a figure

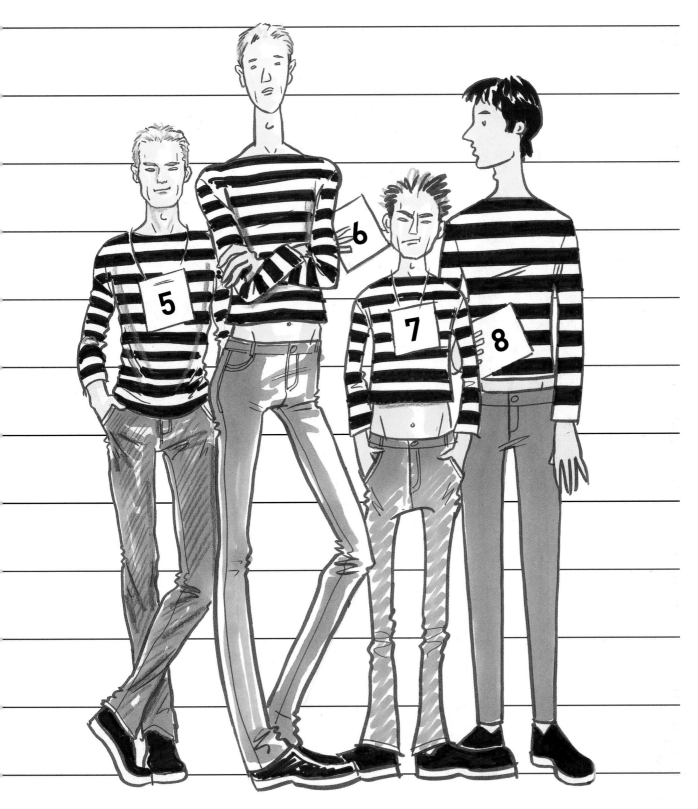

firmly on the ground can make the character appear quite tough or, conversely, surprisingly childlike.

By all means do experiment, but keep in mind that if the body is over-exaggerated then it may be difficult, if not impossible, to fit in important details when you create an outfit. If your template adheres to classic proportions the design process is usually easier and you will avoid unnecessary problems. Experimentation and critical evaluation of both the

drawing style and the content will help you achieve the right balance between wit and individualism and sound artworks that will showcase a design in a believable and attractive manner. If you do choose to follow a more offbeat path, support the illustration with a set of clear flats (see pages 90–2), which will resolve any potential difficulties when actually creating the garments.

CREATING A TEMPLATE

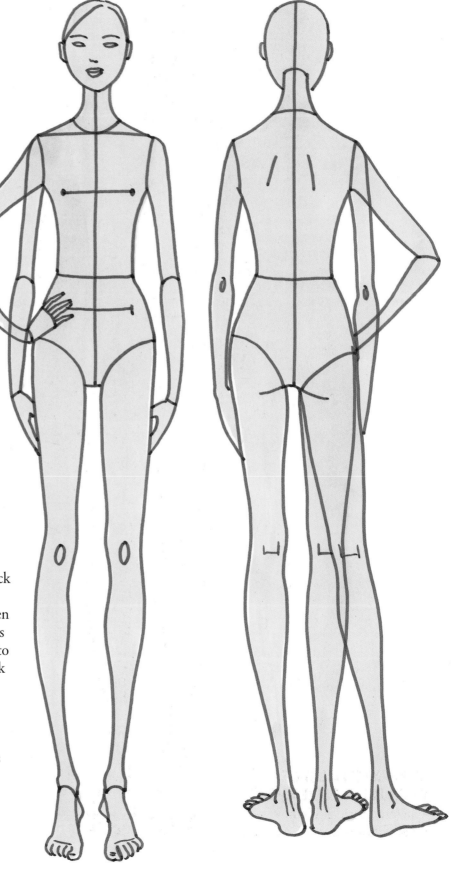

STANDARD STRAIGHT-ON FRONT AND BACK VIEWS: WOMEN

Here we see how to draft a simple straight-on pose, viewed from the back and the front. You can see how the construction lines can be helpful when establishing the garment's design lines and proportions. Most designs need to be shown from the front and the back in order to fully explain the design.

The template also enables you to vary the position of the arms and legs. This is important because you may need to illustrate a detail such as the drape of a skirt or the volume of a sleeve, and altering the pose of the figure will enable you to accurately portray these design features.

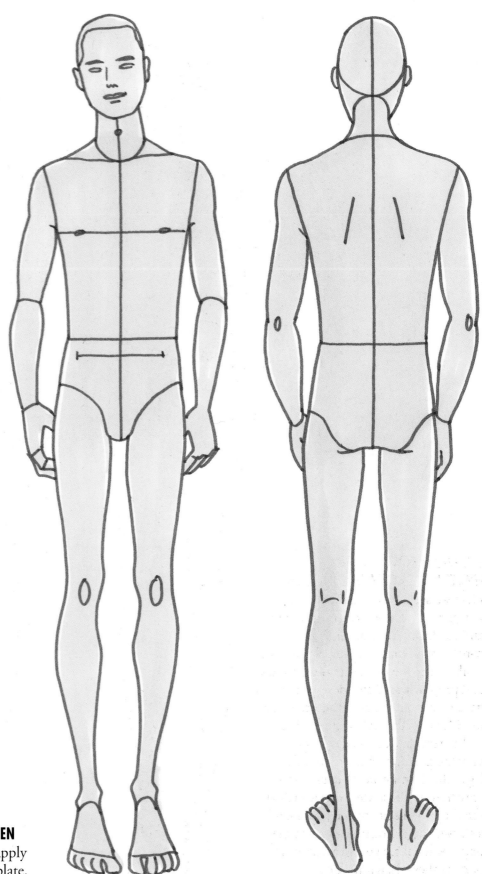

**STANDARD STRAIGHT-ON
FRONT AND BACK VIEWS: MEN**
The same basic guidelines apply
when drafting a man's template.

USING PHOTOGRAPHIC POSES
TO CREATE A TEMPLATE

The first step when choosing a photo of a model upon which to base a figure is to look through magazines or a collection of tearsheets and choose a pose you like – one that suits the mood of your project. The next stage is to replicate the pose by tracing the figure. You will probably notice that the proportions of this real model seem too short and inelegant when compared to the templates described on pages 18–19, so you need to impose a little creative licence and adapt the drawing so it is more in keeping with other fashion figures.

Using tracing paper, or layout paper if you have a lightbox, carefully draw slightly inside the outline of the photographed figure to slim it down into a fashion figure. You should also slightly lengthen the neck and make the head a little smaller too. Add proportion and balance lines down the centre of the figure and across the shoulders, waist and hips, as these will help you add clothes to the finished template.

Now look again at your newly outlined figure, without the photograph underneath it. You may need to slightly refine its proportions and appearance.

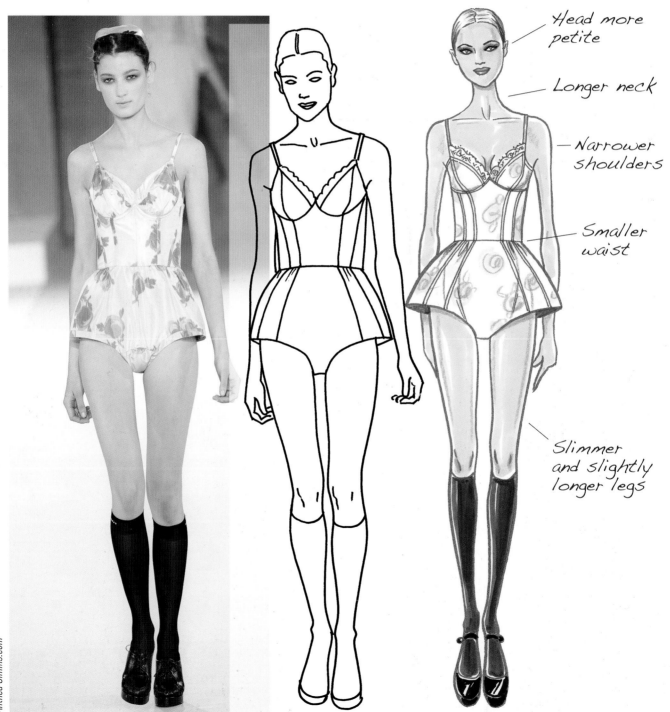

Head more petite

Longer neck

Narrower shoulders

Smaller waist

Slimmer and slightly longer legs

Once you are happy with the outline, either ink it in with a fine-lined fibre-tipped or rollerball pen and erase the pencil marks, or simply photocopy the pencil drawing – the lines should come out black enough to use the copy as your template.

An alternative method is to use scissors or a craft knife to carefully cut out the model. You can then slice the figure widthways into six pieces, slicing across midway each time between the ankles and knees, the knees and the top of the legs, the wrists and the elbows, the elbows and the armpits and finally across the neck. On a clean piece of paper

reposition the photograph, leaving even gaps between the pieces to lengthen the figure to the desired proportions, making sure everything lines up. Once you are happy with the general look, use clear tape to secure the pieces in position and place a sheet of tracing paper on top. You can now trace the outline of the elongated figure. If the final outline is too long, use a photocopier to reduce the template to the correct size.

Both of these techniques can be used for creating templates for men, women and children.

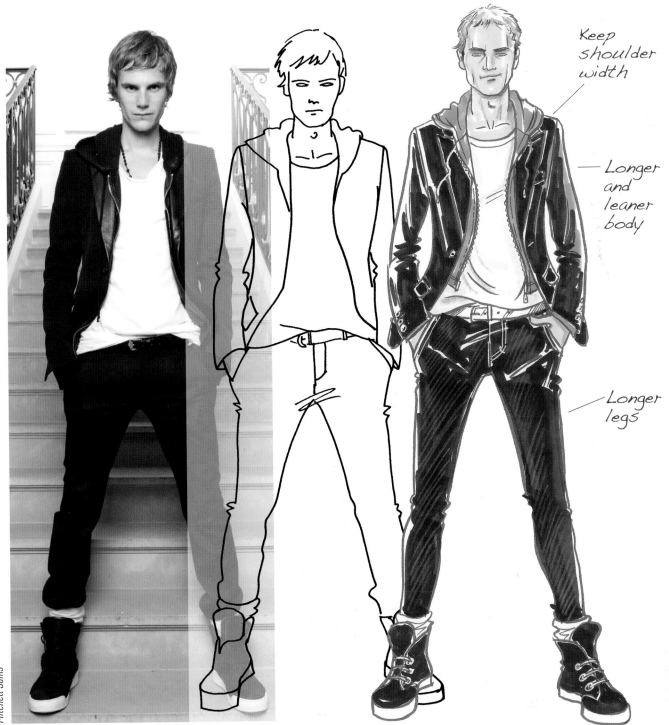

Keep shoulder width

Longer and leaner body

Longer legs

DRAWING HEADS

Having refined the pose of your figure you can now transform it into a model, with an image and identity. Facial expressions are key to creating an attitude or mood, and hair and make-up are strong indicators of period. Collect pages from magazines for ideas and inspiration.

Most heads are roughly egg shaped, and the length of the face is generally the same as that of the hand, which is a useful guide when establishing proportions. Practise drawing a simple, expressionless face to start with, then as your confidence and style develop you can begin to experiment with facial features and expressions to lend the model character.

DRAWING A FEMALE HEAD

1. Draw an egg shape and two lines to mark out a neck. Draw a vertical centre line through the oval. This midline will be used to mark out the position of the features. Remember that if the head tilts to one side, the line will too.

2. Draw a horizontal line halfway down the head.

3. Draw in almond-shaped eyes on the horizontal midline, placing them about an eye's-width apart.

4. Mark the positions of the nose and mouth by dividing the lower half of the face into thirds.

5. To mark out the width of the nose and mouth, draw downward vertical lines from the inner edge of the eye to give the width of the nose, and the inner edge of the iris to show the width of the mouth. You can also roughly check the width of the neck by drawing lines vertically down from the outer edge of the eyes. The top of the ears should roughly align with the eyebrows, and the bottom with the base of the nose.

6. Try adding some hairstyles. Remember, drawing hair does not involve showing every hair on the head – that's not what you see when you look at someone. It's the overall shape, colour and maybe a sense of movement that make an impression, and this overall look is what you should try to produce. The hairstyle you want to draw will affect your choice of medium. For fashion designers, the hair is secondary to the clothes, and they aim merely to give a quick impression of a style that works with the look. A few deft strokes with a brush pen can often be very effective and, with a little practice, a smudge of oil pastel can produce a wonderful Pre-Raphaelite mane or a frizzy 'Colette' bob. Rough scribbles rarely work and tend to look messy rather than chic. Have fun experimenting.

1

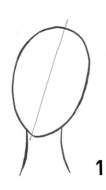

2

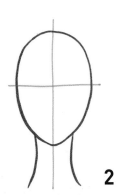

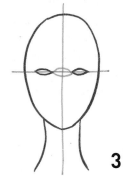

3

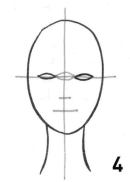

4

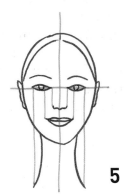

5

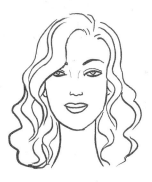

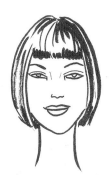

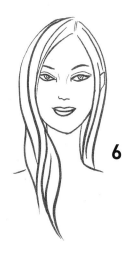

6

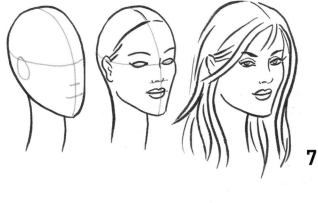

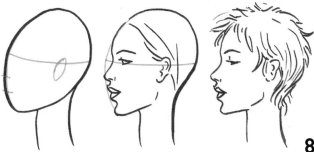

7. The same principles for drawing a head front-on apply when showing a three-quarter view.

8. The same applies to a profile view.

9. Here we can see that the hand is roughly the same length as the face, from the hairline to the chin.

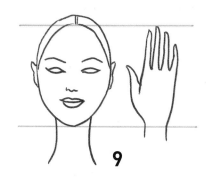

DRAWING A MALE HEAD

Men's heads are frequently proportionally a little larger than women's, and following this guideline certainly helps to make a fashion drawing work better. Begin with a very basic shape. Here the egg shape is somewhat squared off and the squarer chin and jaw line gives the face a masculine look. The neck will also be a little thicker than a woman's.

Again, when adding hair you're drawing an impression of shape and colour, not every strand. A broad stroke with a marker pen or a few waves drawn with a brush pen should suffice. Practise drawing people you know and using tearsheets from magazines as additional references for styles.

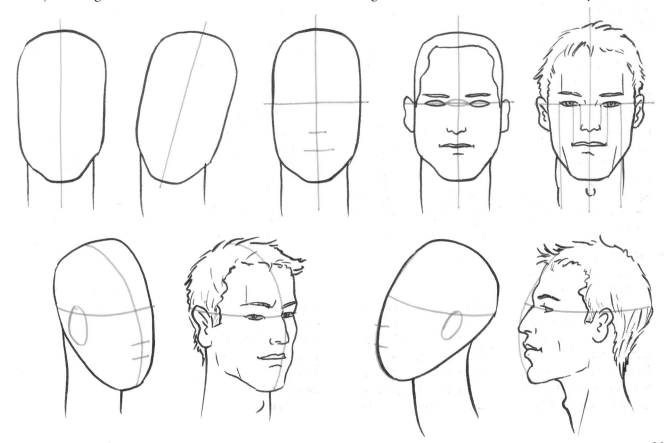

DRAWING HANDS AND FEET

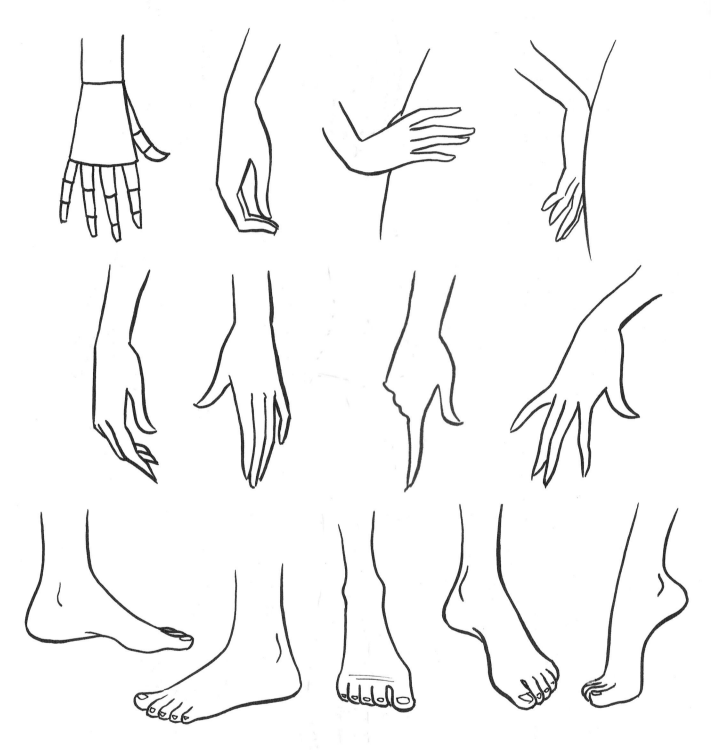

The hands and feet are often the body parts many people struggle to draw, and innumerable half-decent illustrations have been spoiled by the presence of claws or mittens for hands, blobs for feet, or tapering-out legs and no feet whatsoever.

Remembering the guideline that the length of the hand should match the length of the face will help you to get the right scale and proportion. Another

useful rule is that the distance from the wrist to the beginning of the fingers is approximately the same as the length of the fingers themselves. The trick is generally to keep it simple, with minimal details, and to break down the construction into basic shapes.

The illustrations above show a female hand and foot in various positions. Have a go at copying the drawings, then try drawing your own hands and feet.

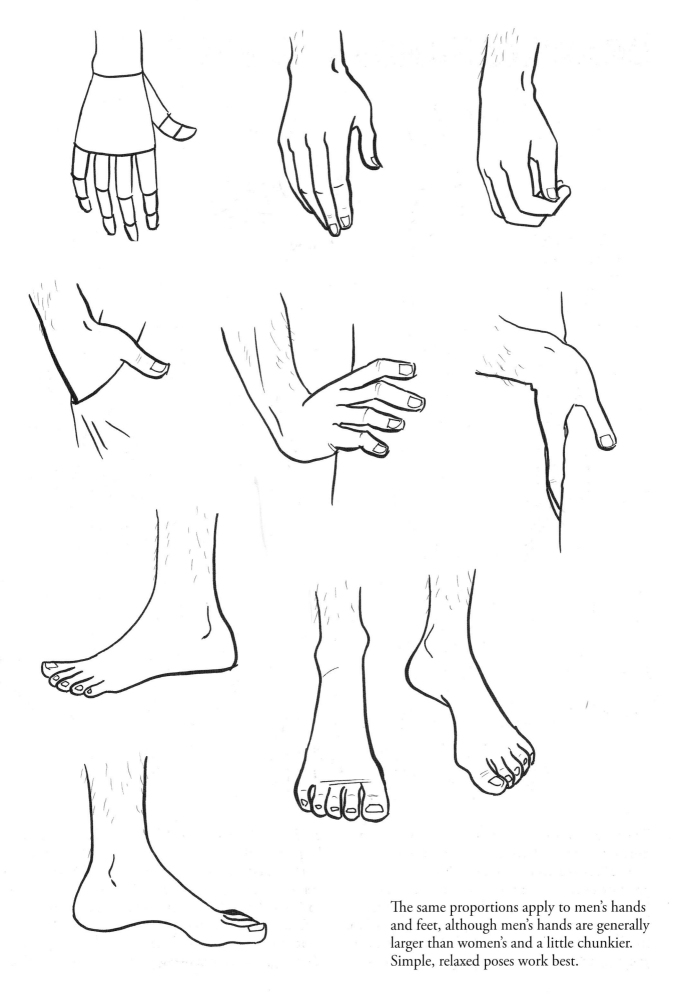

The same proportions apply to men's hands and feet, although men's hands are generally larger than women's and a little chunkier. Simple, relaxed poses work best.

EXTRA POSES AND MOVEMENT: WOMEN

THREE-QUARTER AND SIDE VIEWS

When choosing a pose that best showcases a design, it is often useful to be able to draw three-quarter and side-on views in order to reveal certain design features. The same basic rules used for straight-on or back views apply, but drawing a figure from a three-quarter or side-on angle is a bit trickier as you need to consider perspective more.

When drawing any pose it can be helpful to adopt the position yourself and look in the mirror. Notice whether your body is twisting, the position of your shoulders in relation to your hips, the position of your feet and how the weight is distributed. Ask yourself questions. How are you balanced? Is one leg taking more weight than the other? Which parts of the body are nearest or farthest? As you draw, go over these points in your mind – you'll be surprised how it informs and improves your drawing.

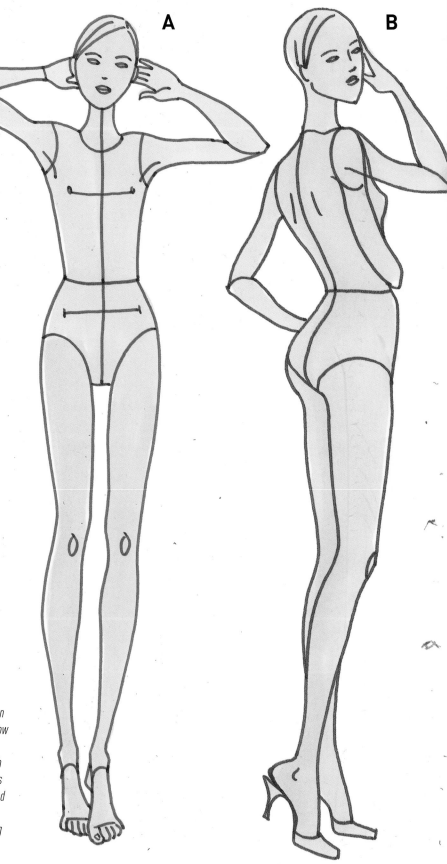

A *Straight-on pose showing raised arms.*

B *As well as looking quite relaxed and natural, three-quarter turned and side-on poses are perfect for showing side details such as pockets and seaming features on jeans and trousers.*

C & D *These may be seen as static poses or, in conjunction with illustration E, as being depictions of how the body looks mid-step. As the body travels through a stride, the spine becomes more tilted and the hips and pelvis move forwards. The weight is carried by one leg as the other steps.*

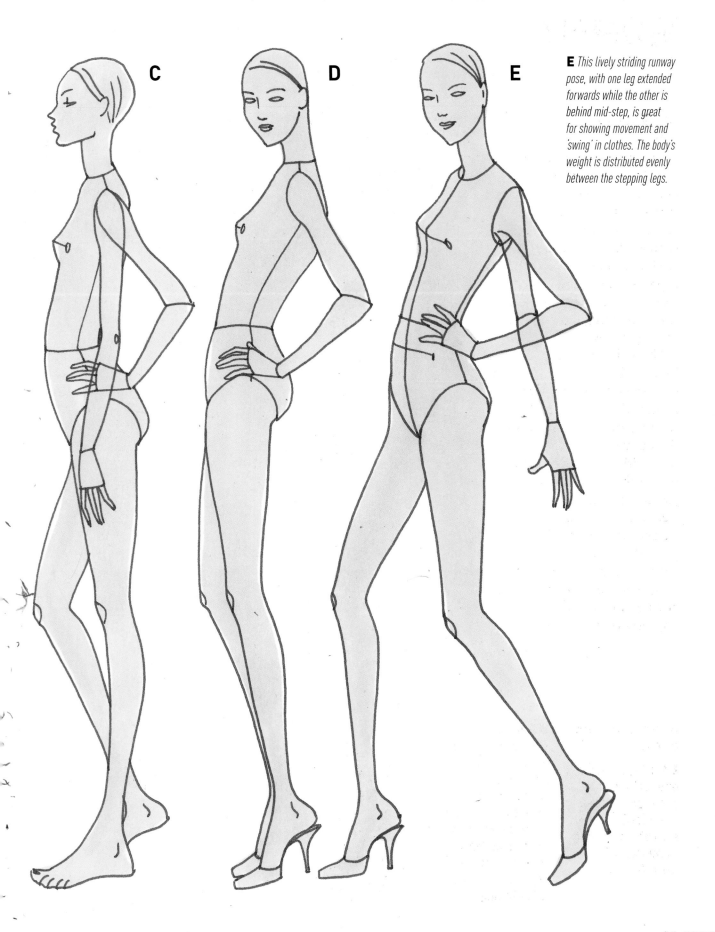

C

D

E

E *This lively striding runway pose, with one leg extended forwards while the other is behind mid-step, is great for showing movement and 'swing' in clothes. The body's weight is distributed evenly between the stepping legs.*

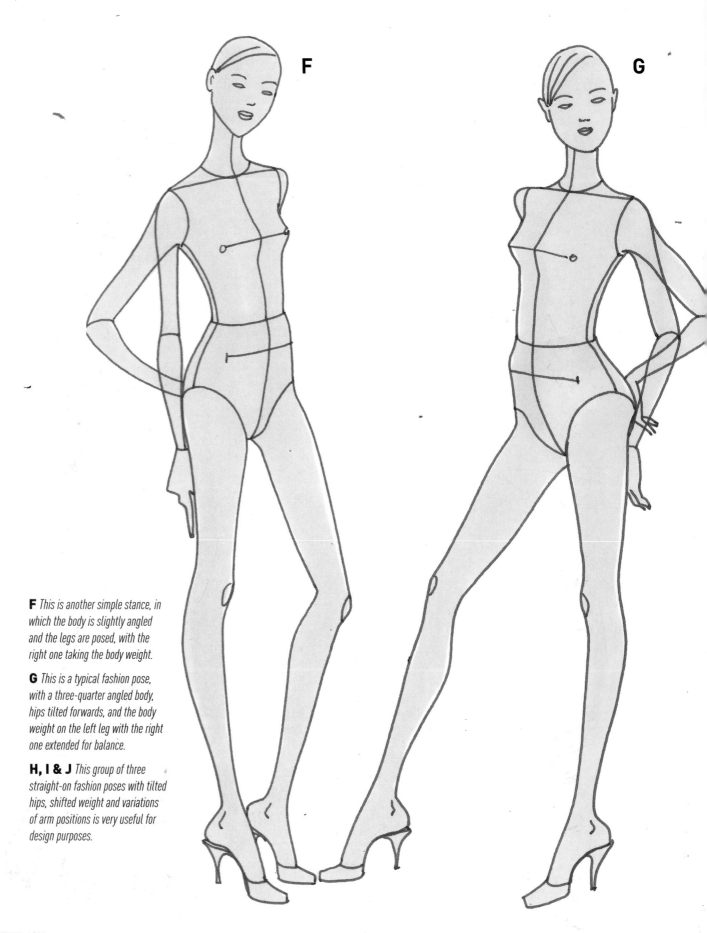

F This is another simple stance, in which the body is slightly angled and the legs are posed, with the right one taking the body weight.

G This is a typical fashion pose, with a three-quarter angled body, hips tilted forwards, and the body weight on the left leg with the right one extended for balance.

H, I & J This group of three straight-on fashion poses with tilted hips, shifted weight and variations of arm positions is very useful for design purposes.

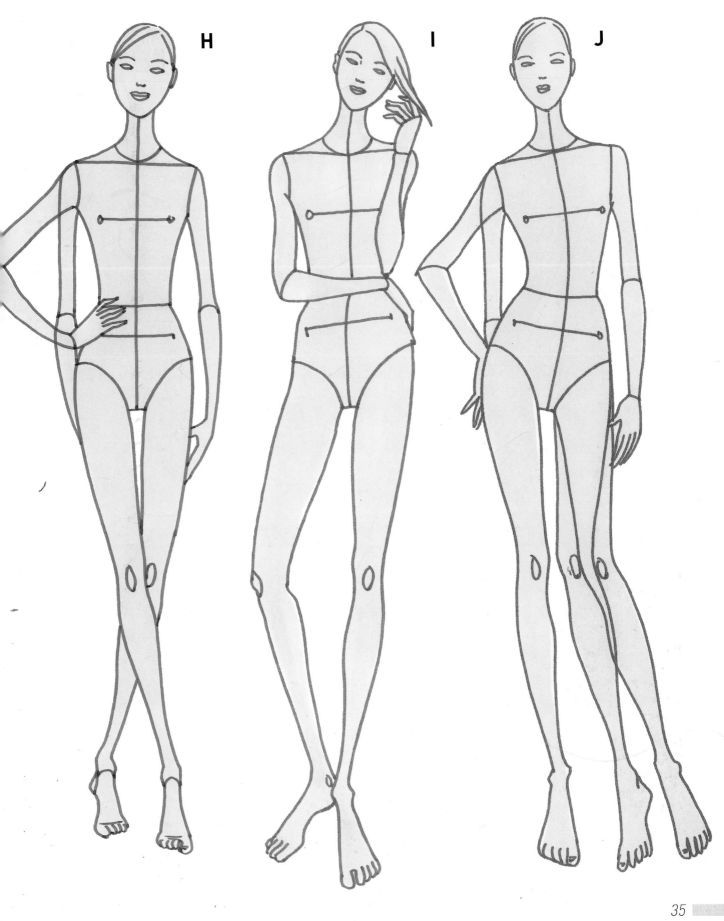

H I J

EXTRA POSES AND MOVEMENT: MEN

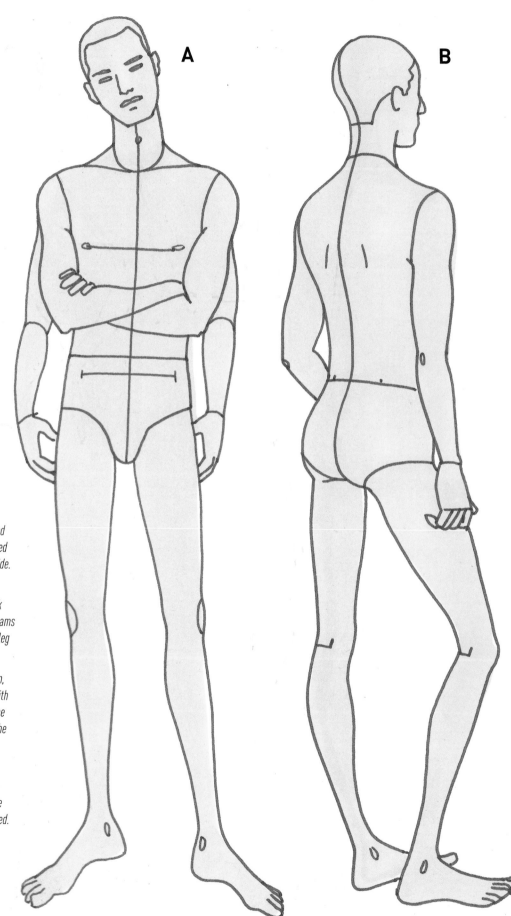

A This is a simple, slightly relaxed straight-on pose that is emphasized by the tilting of the head to one side. Body weight is evenly distributed.

B This slightly three-quarter back view would enable you to show seams and pockets on trousers. The left leg bears most of the body weight.

C Viewed more or less straight-on, this pose is casual and relaxed, with the crossed leg balancing while the right leg takes the body weight. The hand could be positioned behind the back or in a trouser pocket.

D This is quite a relaxed straight-on pose in which the shoulders are slightly tipped and the head is tilted. The right foot is carrying the body weight, while the hands could be buttoning a jacket or fastening a zipper.

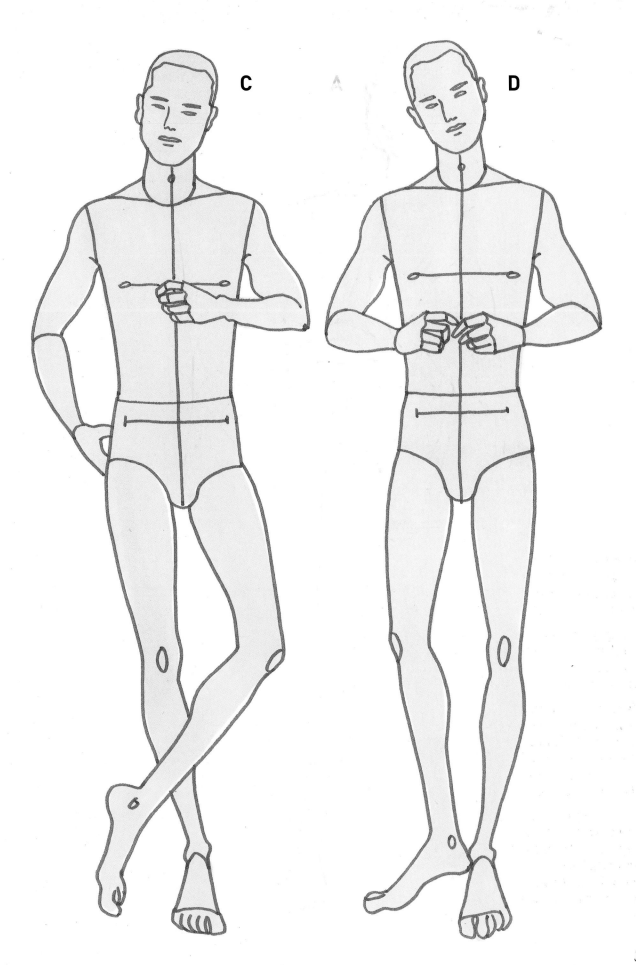

C

D

E *In this three-quarter front pose the head is facing forwards and the crossed leg is casual rather than contrived. The straight right leg carries the body weight while the tipped foot balances.*

F *This three-quarter front pose shows movement as the model is mid-step, with the right leg carrying the majority of the body weight as the left foot lifts slightly. The shoulders are pulled back and the head is also shown from a three-quarter view.*

G *This is a simple side view of a figure mid-step with the left leg taking the body weight. The head is also seen in profile. Seen with illustrations H and I, this pose could be part of a walking or runway sequence.*

H *This mid-step three-quarter pose shows a three-quarter view of the face, the left foot taking the body weight and the right shoulder swinging forwards with the stepping right foot. The shoulders are down as the hands rest on the hips.*

I *This pose depicts the continuation of the movement shown in illustration H. The right foot has landed and the body weight is more evenly distributed, but the left leg still carries more of the weight. The shoulders are pulled back a little and the chest is lifted.*

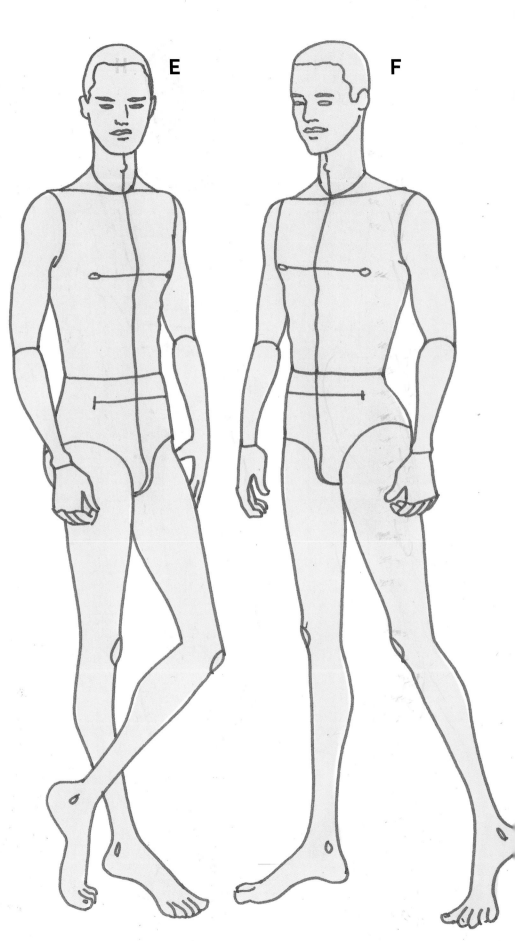

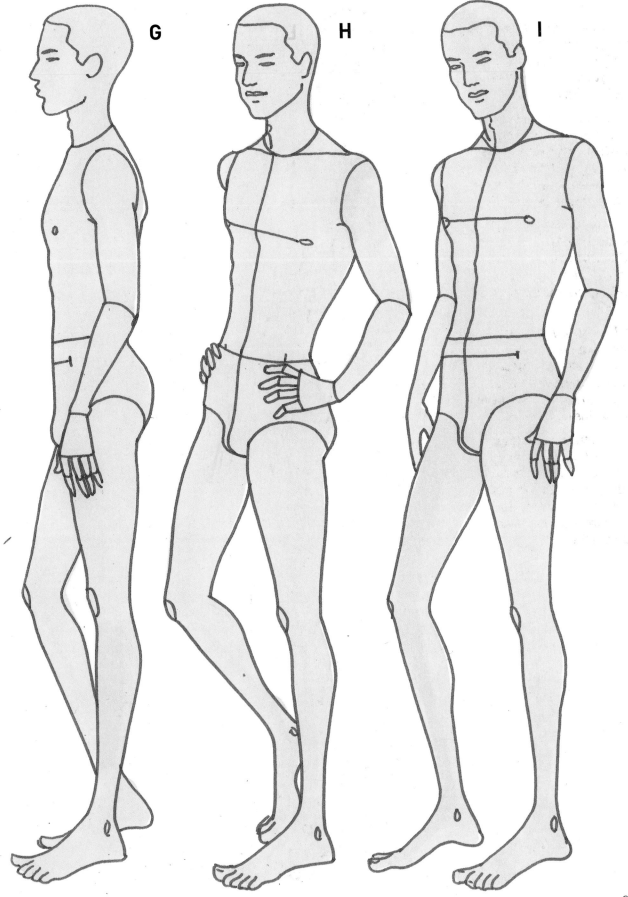

G H I

CHAPTER 3

KEEPING AND USING A SKETCHBOOK

We have already covered the different types of sketchbooks available in stores in Chapter 1, but there is nothing to stop you making a sketchbook yourself from an interesting collection of papers, or indeed from finding a vintage book and using that as a starting point. If the book contains images and text that are somehow related to your project then retain them, otherwise you can stick new paper over pages or white out existing material with household emulsion paint. If you choose to buy a new sketchbook, then you should make it your own, especially if it has a company logo on the front. Cover it with interesting paper that works for your project or photocopy one of your own drawings and paste that on to the jacket.

It may be appropriate to have a separate sketchbook for a particular project or assignment, which will allow you a focused space for the development of your designs. But it is also a good idea to have what we might call a 'general sketchbook' or 'ideas book', in which you regularly jot notes and make quick sketches recording a thought, idea or observation. Be a magpie – gather all manner of information in the form of samples of colour, postcards, images, bits of packaging,

smudges of paint, snips of fabric, corners torn from magazines, press cuttings and magazine tears, addresses and information about exhibitions and fashion blogs – anything that reminds, records and inspires your creativity. However, whatever else goes in your sketchbook remember that the clue is in the name – you should sketch in it!

When using a sketchbook you should not necessarily consider a possible future reader – it should be the place where you record, create, formulate and document the development of ideas as well as solve problems, either in written or drawn form. However, if you know that a tutor, boss or client is likely to want to see the sketchbook then it is worth ensuring that everything is clear and appealingly presented. Bearing an audience in mind may also help you during the development stages, enabling you to clarify thoughts and consolidate a concept by anticipating reactions and questions.

Finally, a real sketchbook should never be put together at the end of an assignment or project; it should be a progression of ideas that leads to a conclusion in the final designs and ideas, like the logbook of a creative journey or voyage of discovery.

SKETCHBOOK INSPIRATION

Here we can see examples of how, during the early stages of a project, ephemera and 'found images' such as postcards of paintings, magazine tears or photographs can be used to inspire and create the beginnings of ideas in a sketchbook. All the examples shown here are by students from the University of Brighton, UK.

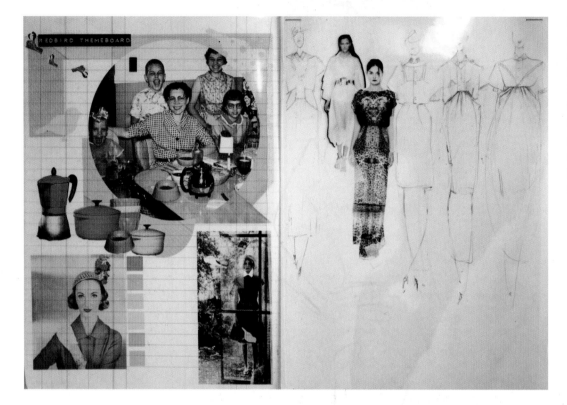

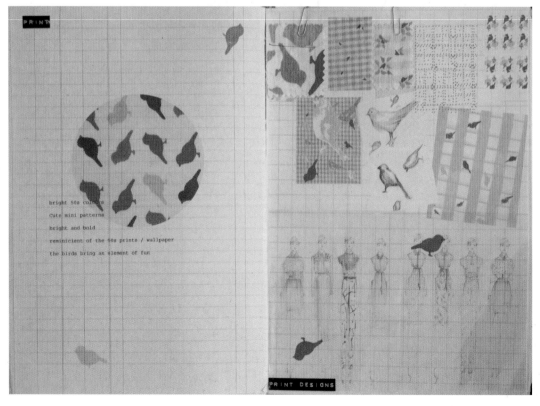

LEFT & BELOW: *This piece by Bryony Cooke builds a charming theme around the story of* I Capture The Castle *by Dodie Smith, and explores a nostalgic, domestic, 1950s 'make-do' look with fresh colours, simple gingham-type fabrics and a quirky little bird motif.*

essing from see-through bras to panty shorts and corsets brings with it the

CORAL PROJECT by Karen Fehr

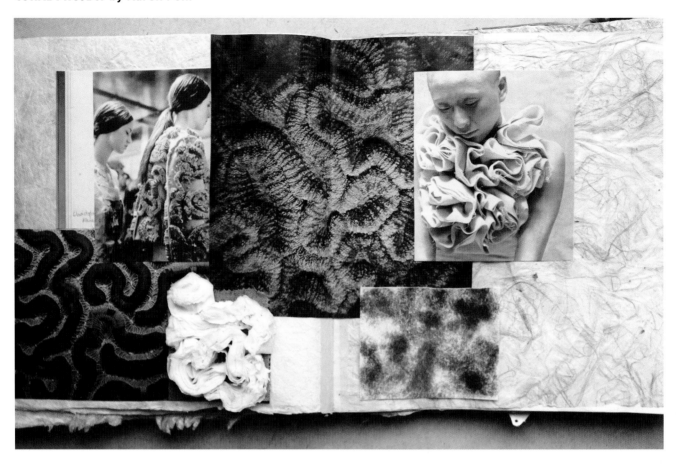

ABOVE: *In this project Karen Fehr (a student at the American Intercontinental University) has chosen coral and the ocean floor as the theme, looking at patterns and textures as the inspiration for fabrics and fabric manipulation techniques. Other found images that are visually related have been added to enrich the imagery.*

BELOW: *Here experiments with fabric painting and simple printing techniques echo and interpret collected photographic images. Found fabrics that evoke the textures and colours have also been added. Garment ideas begin to explore ways of using these fabrics and techniques.*

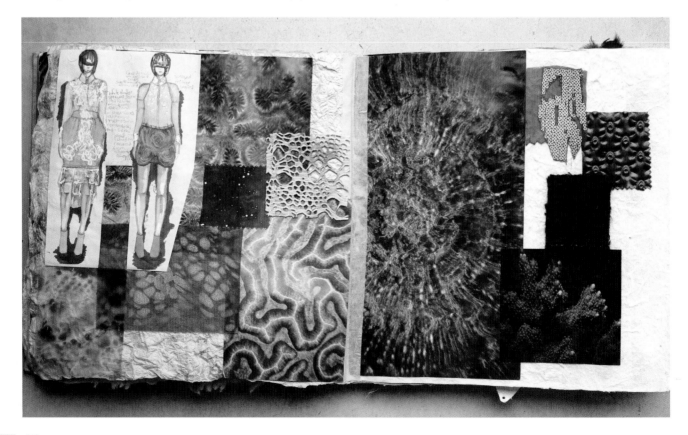

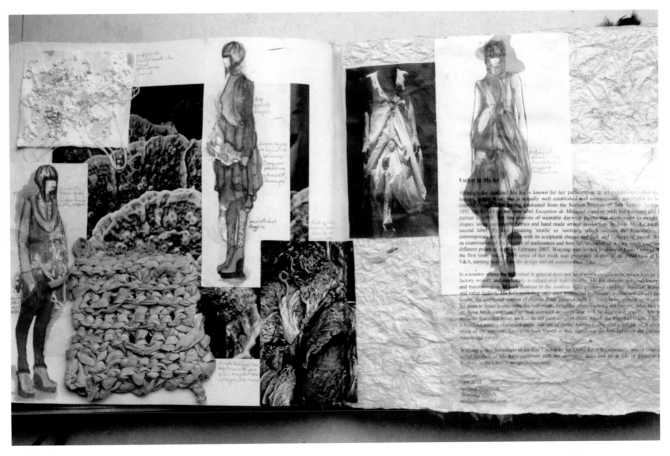

ABOVE: *Additional pages of rough hand-made Indian paper that evoke the rich textures of the theme have been inserted. The forms and structures bring to mind silhouette and volume. Images that suggest fabric textures and inspire knitting using shredded fabric as yarn have been included. Embroidery and embellishment ideas are created using beads, plaster of Paris and paint, for a modern, unconventional interpretation.*

BELOW: *These drawings are inspired by studies of coral, and show initial garment ideas and experiments on the dress stand.*

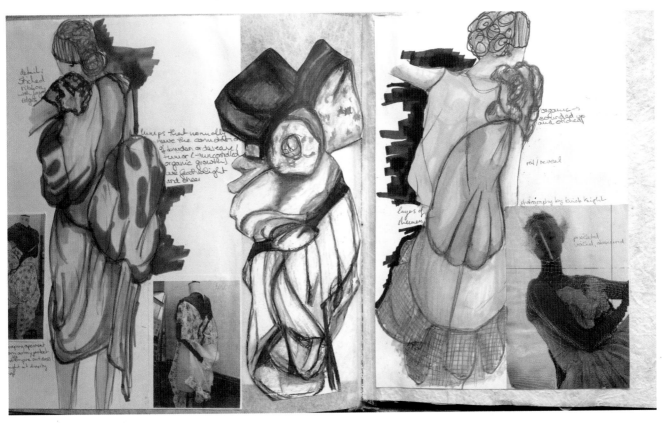

RESEARCH AND DESIGN

Sketchbooks are inseparable from research and design. If your sketchbook is a logbook of your journey, then research is what you observe, discover and find inspiring on that journey, and design is how you filter, generate and connect ideas and thoughts and focus them into some kind of conclusion; an end concept or product. Research is what stimulates ideas. There is also practical research, which might be enquiry into techniques, processes, fabrics and materials, and this informs and makes those ideas happen. Design development is essentially the aesthetic and practical process of cycling through many permutations of one idea – which will often lead you to more ideas – and by evaluating, refining and critically assessing those themes eventually arriving at a finished design.

Although found material, as already discussed, is very important for stimulating ideas, the work that appears in a sketchbook should be mostly primary research, that is to say things you have drawn and researched first-hand: photographs you have taken, experiments and discoveries made by going, doing, seeing and experiencing things for yourself. The more personal your research, the more individual your creative outcomes will be. Allow yourself to be inspired by almost anything, from a holiday or museum trip to something more obscure and esoteric, and build upon that first spark of an idea, developing a thread that leads from initially random inclusions in your sketchbook to a definitive

conclusion. If your starting point is, for instance, Ancient Egypt, you should eschew obvious mainstream sources of information, such as the innumerable books on the subject, and instead find out whether a collection is being exhibited in a museum or country house and if so go there yourself to draw and photograph (where possible) inspiring artefacts. You might watch some old movies too, and find out about other fashion trends that have been influenced by the same theme over the years, such as the passion for Egyptian styles in France and Regency Britain following Napoleon's campaigns in Egypt and Syria in the late 1700s. Thus it is easy to see how making connections and imaginative leaps and layering influences can help you develop an idea and lend it a personal slant; it's a bit like following a basic recipe and adding some alternative ingredients to give it a twist. Research is exciting: expect the unexpected.

Inclusions in your sketchbook research may be drawings, images or notes or other information about colour, shapes and pattern, form, texture, fabrics and materials, construction, detail, atmosphere, scale, history or background. You should cross-reference or juxtapose images or details within images. The relevance of images and the connections between one image or idea and another should become apparent; as you progress, your creative thought process should be evident and purposeful, not least to you.

DUSTER COAT PROJECT by Yvonne Deacon

1. *This project takes inspiration from a favourite vintage find – a linen duster coat or warehouseman's coat from the 1930s. Other found images were combined to set a mood, including an old grocer's bill and a black and white photograph of a grocer's shop from the early 20th century, with the grocer himself proudly standing in front of his wares. A painting by Cézanne showing a card player wearing a similar coat was also included, together with nostalgic old photographs of a small boy in interesting clothes and a girl on a bike in a print dress. A few swatches of coarse linen and a winding of red thread were later translated into the red stitching feature that appears on the final design.*

2. *A flat or semi-diagrammatical sketch was made of the coat, revealing its lovely details and proportions. The utility aspect was deemed important and this was enhanced by the inclusion of scraps of coarse, hardwearing linen that demonstrated its surface finish, texture and colour after many washes. A charming pencil and crayon sketch of a thrush with its chest puffed-up and wings akimbo provoked ideas about air and volume, and its subtle plumage, along with vintage-look floral fabrics inspired by the bicycling girl, led to the development of the colour story. Loose sketches record and develop initial ideas and silhouettes and combine to build the mood.*

1

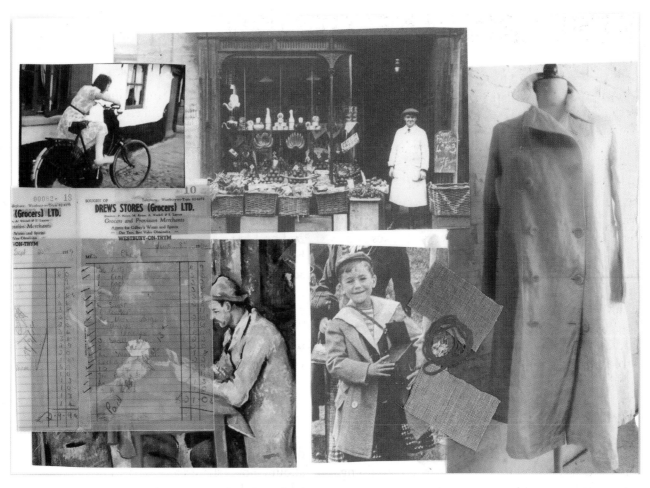

2

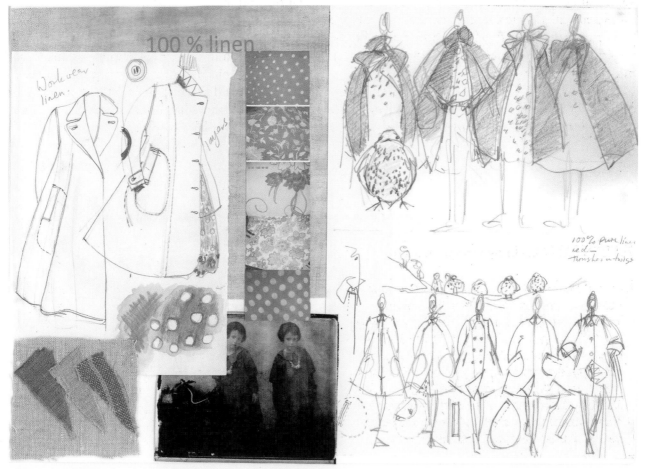

3

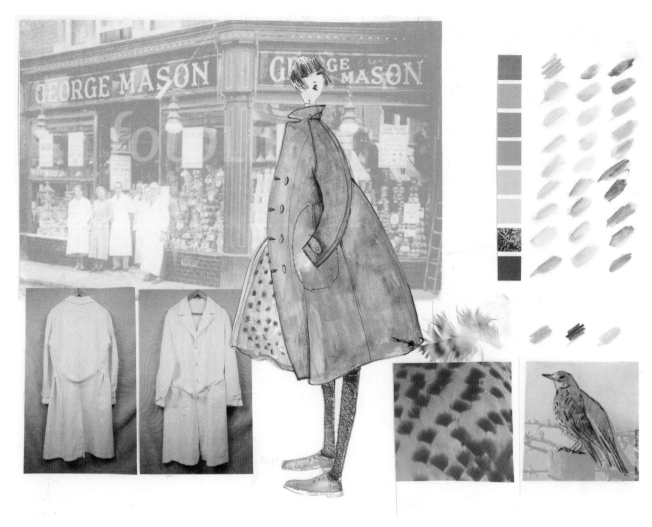

4

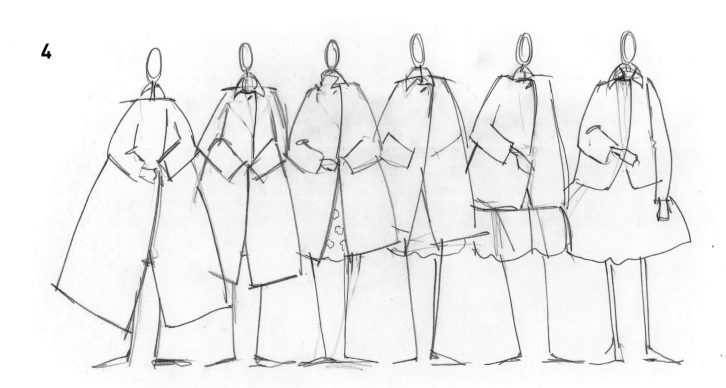

3. *The theme and atmosphere are clarified in a 'mood board' showing other researched, drawn and found images. Photographs of the actual coat show the thought progression and are supported by a painted and collaged colour palette.*

4. *'Design development sheets' show the development of the design ideas. The silhouette is drawn and redrawn, with proportions and details being exaggerated and explored repeatedly.*

5. *Further series of design developments refine the possibilities for the coat, which is to be the key item in this capsule collection. The functional appeal of its pockets and details are enhanced with bold stitching.*

6. *The notion of layering – which goes back to the source of the idea in terms of overalls, aprons, protection and volume – is explored in this series of developments.*

5

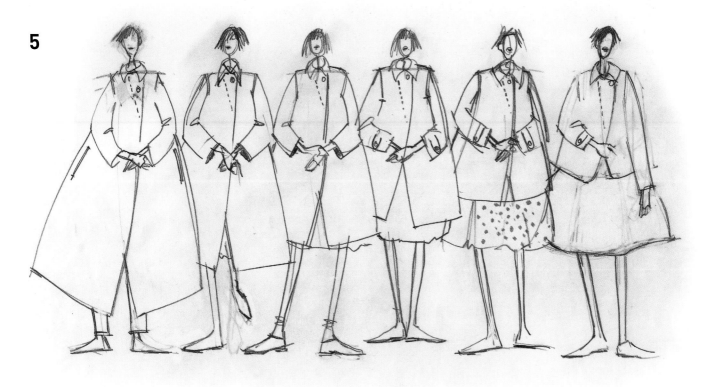

6

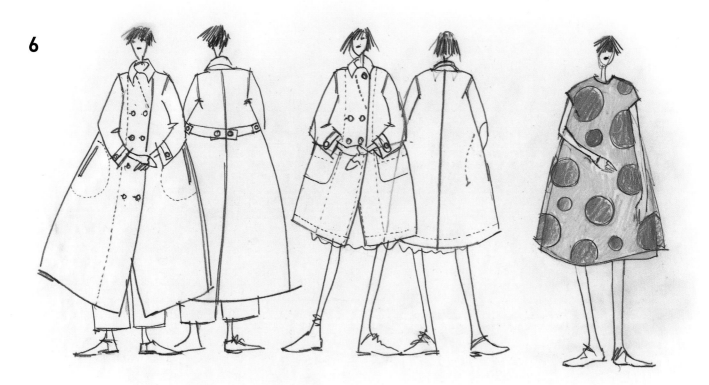

49

7

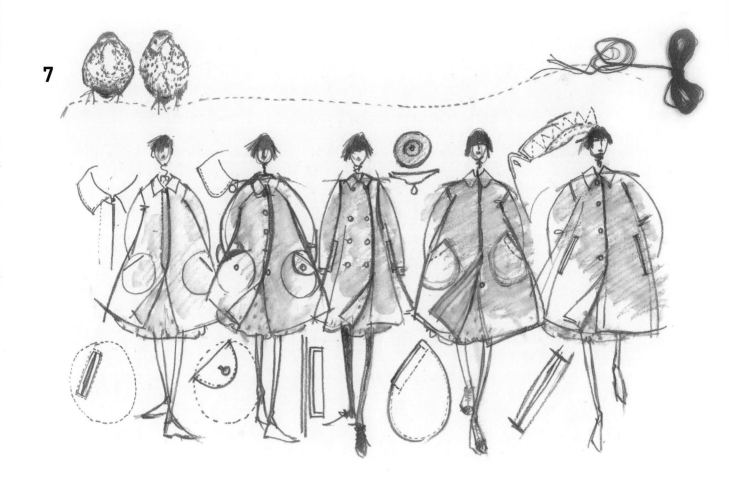

8a

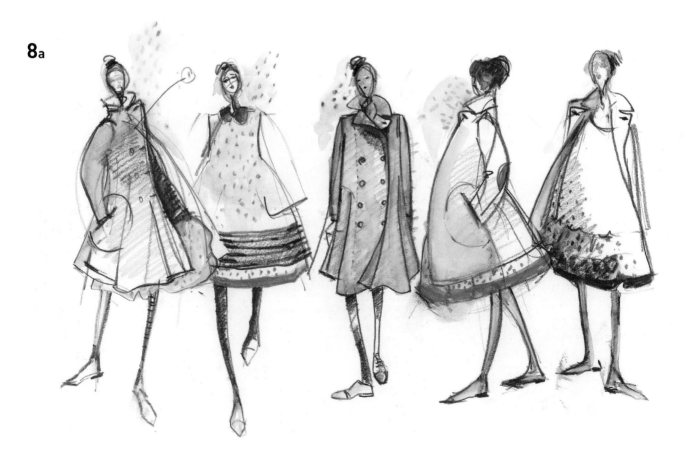

8b

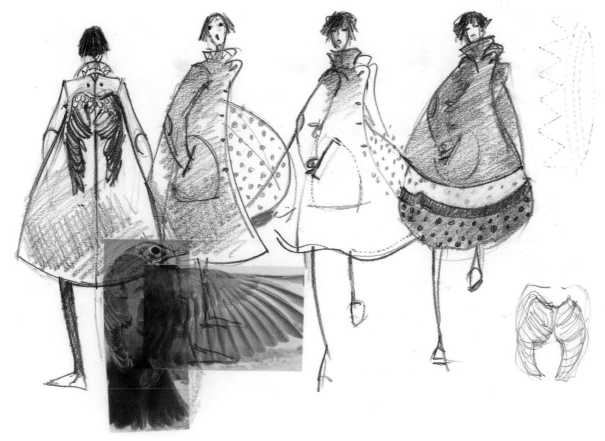

7. The ideas are further developed to include a more literal interpretation of the thrush, with ideas for embroidered wings and speckled and spotted fabrics.

8. The project finishes with a series of more precise design drawings showing the refined ideas and details, and these are clear enough to be used for starting to make up the designs. The last illustration (8c) consists of a precise drawing on tracing paper layered over standard paper on which fabric colour and pattern have been rendered in a loose, interpretive way. This technique complements the layered aspect of the garment's design.

8c

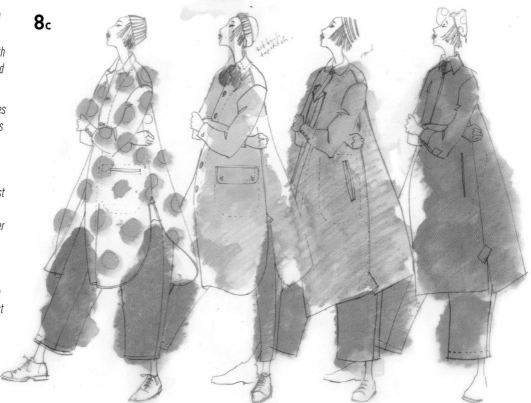

HAMPSTEAD BEATNIKS PROJECT by Yvonne Deacon

1

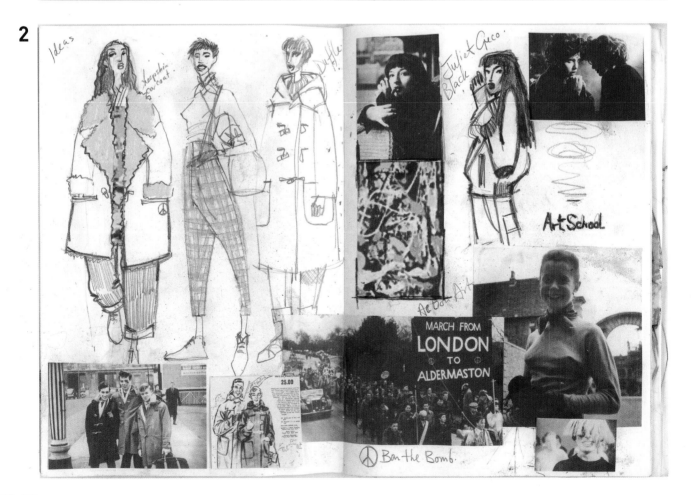

2

1. *This project is based on a theme inspired by the designer's favourite period films and family memories of the artist-bohemians of Hampstead in north London, UK, in the late 1950s. As Hampstead was Britain's answer to the Left Bank in Paris in the same era, images of French film stars and ballet dancers are collaged and combined. Images, sketches and notes for looks, styling and fabrics record initial brainstorming.*

2. *Nostalgic old photographs of peace marches and vintage advertisements for the beatniks' preferred utility garment, the duffel coat, are collected as the theme develops and broadens.*

3. *Images of artists and their abstract art, riverside stalls selling paintings, and the bohemian style of the movement's followers inspire more ideas and designs.*

4. *Artist's painting smocks and the original 'boyfriend' looks of the era begin to combine and suggest silhouettes and styles. An image of a rather wild but stylish young woman recurs and is chosen as a muse/model for design sketches. A small watercolour sketch of a paintbox thematically expresses a colour mood.*

3
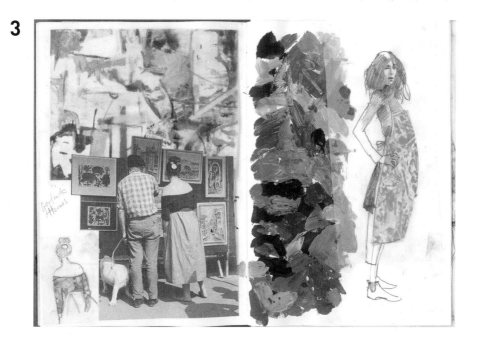

4
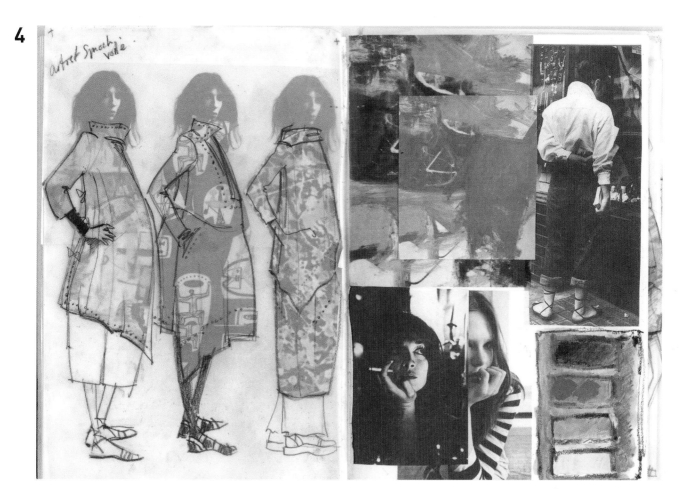

5

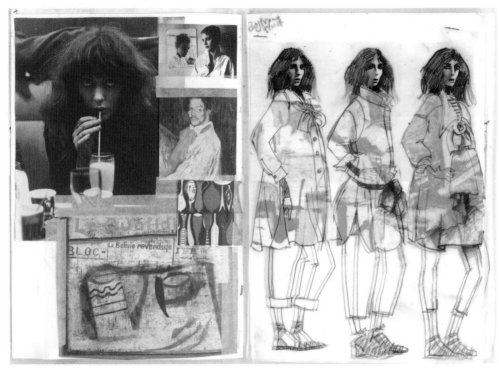

5. *The look is reinforced with images of a 'boyfriend' shirt, vintage printed fabrics and 'coffee bar' style. Design ideas for artist's smocks are developed and refined.*

6. *Other bohemian additions include vintage lace, aprons, oversized proportions and abstract prints, which are collaged together and create another wave of design ideas.*

7. *Ideas of 1950s café society in London and Paris and of the glamorous notion of vintage Parisian fashion combine to upgrade the ideas for a more runway look.*

8. *Finally, a more sophisticated amalgam of all the ideas emerges, embracing all the elements, including the jazz sounds and imagery of the era.*

6

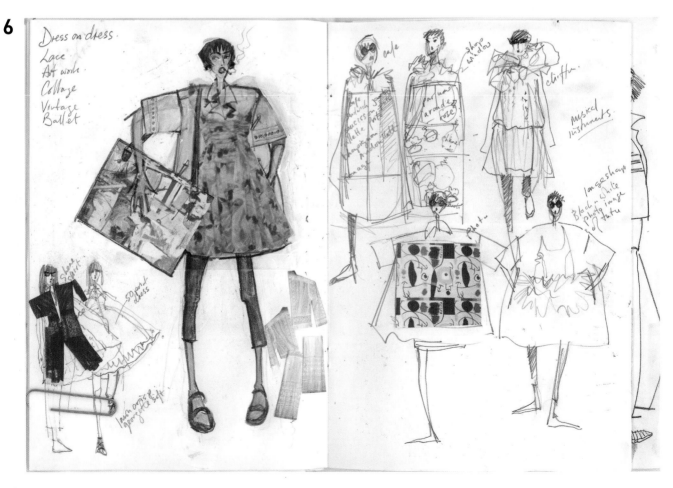

7

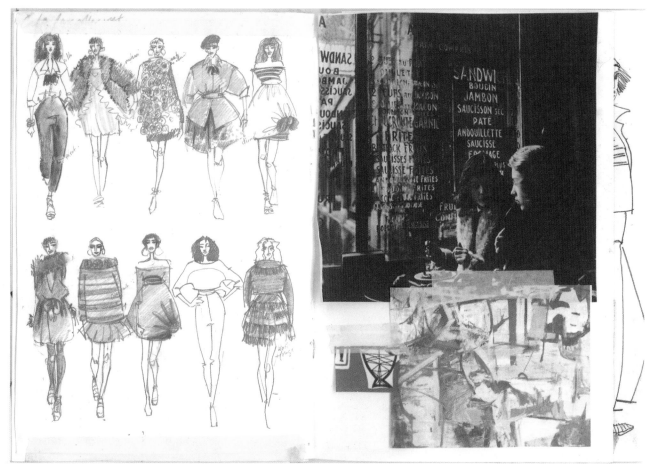

8

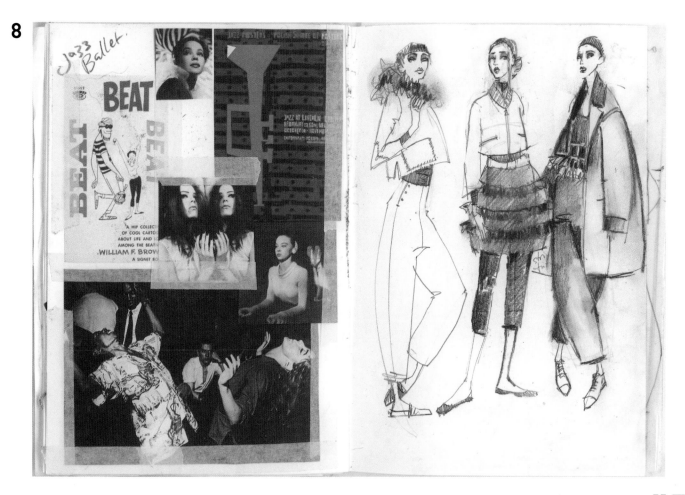

DRAWING FABRIC

Once you have mastered the basics of figure drawing and creating effective poses, the next stage is learning how to draw the clothes. This is rather like making them, so this section reveals how to draw fabric as part of that process. It is a good idea to develop an understanding of the range of fabrics available, as this will enable you to realize how integral cloth is to the character and identity of garments. How this knowledge informs your designs is part of the next step; it is not about replicating a piece of fabric on paper (although that is good practice), it's more about developing your own visual shorthand.

Wherever possible try to have samples of the fabrics in front of you, or at the very least some magazine tears of similar fabrics so you know what you are trying to represent. Then try out a range of different mediums until you achieve something you are happy with. Always allow yourself time both to experiment and to create the actual artwork, taking into account drying times for mediums such as paint and glue. As with most creative work, a little planning in advance will help you to achieve the best results.

BASIC TECHNIQUES FOR RENDERING FABRIC

Choosing a suitable type of paper is the first stage. Very smooth paper is perfect for depicting satin or shiny fabrics, while watercolour paper may be better for showing rustic tweed or a soft mélange knit. These papers can then be collaged into your drawings. Similarly, you can scan or photocopy the actual fabrics, reduce the scale right down and stick them on to the page as required.

Having drawn an outline of the design, you can lay down a base colour using a marker pen, paint or oil pastel, and then work more detail in with crayon, fibre-tipped pens, ink, gel pens, oil or all of the above! You could also start by using a 'resist' for part of the detail, which involves blocking out an area with wax crayon or a candle or with professional watercolour masking fluid. You then apply a base colour over the top and the detail will remain uncoloured. If you are using masking fluid, remove it once the base paint is dry. You can then add more detail using another medium. This method can work particularly well for damask and lace-type fabrics with shadow or sheen effects, or for those materials with a bolder positive/negative aspect.

WHITE FABRIC

Drawing white fabrics might seem like an easy option, but varying their characteristics brings its own set of challenges that need to be surmounted creatively. In these examples, surface lustre and texture are cleverly suggested using bold strokes and a sensitive choice of mediums that reflect the type of material being depicted.

Voile is a type of fine, sheer fabric. Traditionally, it was always expensive as it was technically more challenging to create fine fabrics, and so was used for special-occasion garments, such as party or wedding dresses, fine shirts and so on. Other sheer fabrics include chiffon, georgette and tulle. These days, thanks to mechanization and man-made fibres, such sheer fabrics have become more affordable and available and are no longer associated exclusively with occasion wear.

Traditionally, lurex and lamé fabrics have metallic threads woven into them, but modern versions of these materials often also incorporate synthetic fibres, and metallic effects are created using foiling and printing techniques.

In the illustration below, good-quality brown wrapping paper was used as drawing paper and after drafting out the design the outline was inked in. Chalk pencil was lightly applied to the dress and further shading was added using marker pen and pencil crayon.

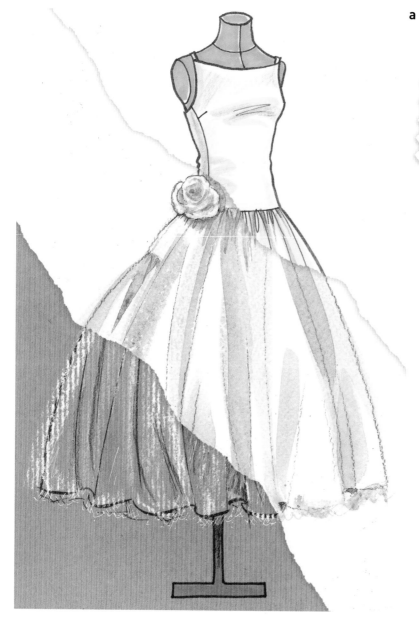

a

b

Sheers and voiles
a. *A base is laid down with marker pen.*
b. *Random cross-hatching is added with fine fibre-tipped pen.*

a

b

Lurex and lamé
a. *A base is laid down with marker pen.*
b. *Random dots and lines and sparkly lines/stars are added using fine fibre-tipped pen.*

Broderie anglaise, sometimes known as 'Swiss embroidery', is traditionally a fine white cotton fabric with a pattern of eyelets hand-embroidered onto it, usually in white thread, although European variants often used coloured embroidery threads. Today, there are many variations on this type of fabric, and it is almost always machine-made.

Crochet is a handmade fabric that, unlike knitting, cannot be created by machine even to produce the most simple stitches and designs. Crochet is used to create pretty openwork patterns for decorative trims and finishes, and sometimes to produce clever bas-relief and 3D effects.

Lace, with some variants known as 'thread-lace', covers a broad family of openwork fabrics, including net. The fabric often has strong cultural roots, and particular regions and countries are famous for the different techniques used and the complexity and design of the finished products. While lace was traditionally handmade, machine-made lace began to appear at the height of the Industrial Revolution and mechanized lace production is still developing today.

Guipure lace, despite its name, is a type of embroidery rather than lace, and so is sometimes known by its proper name 'guipure lace embroidery'. It is created by applying a pattern of thread embroidery to a ground fabric, which is then removed by chemical or other means to leave an openwork lace.

In this example of a 1960s-inspired cocktail shift dress, guipure lace is suggested by employing a little stamp to print pattern on the illustration, using irregular pressure to avoid a flat finish.

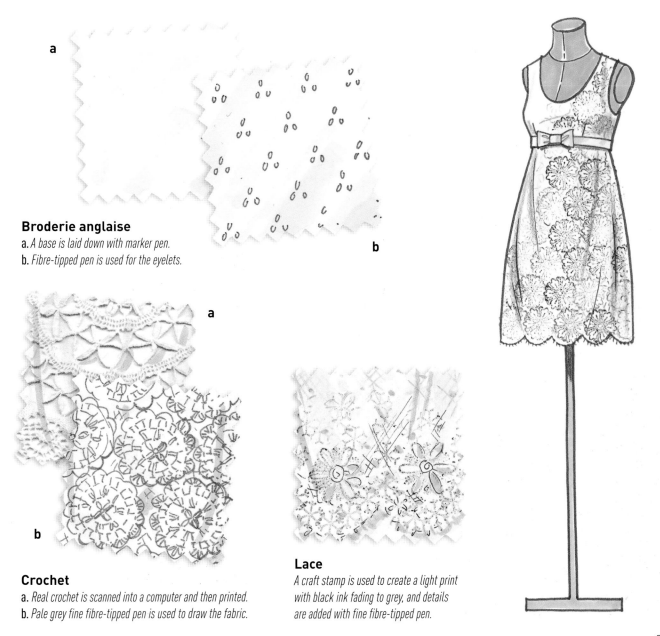

a

b

Broderie anglaise
a. *A base is laid down with marker pen.*
b. *Fibre-tipped pen is used for the eyelets.*

a

b

Crochet
a. *Real crochet is scanned into a computer and then printed.*
b. *Pale grey fine fibre-tipped pen is used to draw the fabric.*

Lace
A craft stamp is used to create a light print with black ink fading to grey, and details are added with fine fibre-tipped pen.

LUXURY FABRICS

This satin evening dress was drawn on watercolour paper in pencil outline before loose, bold strokes of watercolour were added.

Satin is a smooth, generally lustrous fabric with a close, warp-faced woven surface that catches and reflects the light. Traditionally made from silk, many versions made from synthetic fabrics are also available today. Sateen is similar to satin, but is a weft-faced fabric.

Velvet is fabric woven with a pile surface. This is created during the manufacturing process by lifting the warp over wires to make loops, and then cutting them as the wires are withdrawn. Similar fabrics are plush and velour. Terry, sometimes known as 'terry towelling', is created in a similar way, but the loops are not cut. There are knitted versions of all of these types of pile fabrics, which have the advantage of the degree of stretch associated with most knitted fabrics.

Sequins are sometimes known by their French name, *paillettes*. Traditionally, they are small reflective metallic discs sewn onto fabrics, although modern versions come in all sorts of finishes, including matt, transparent, printed and hologram, and in a wide range of sizes and shapes.

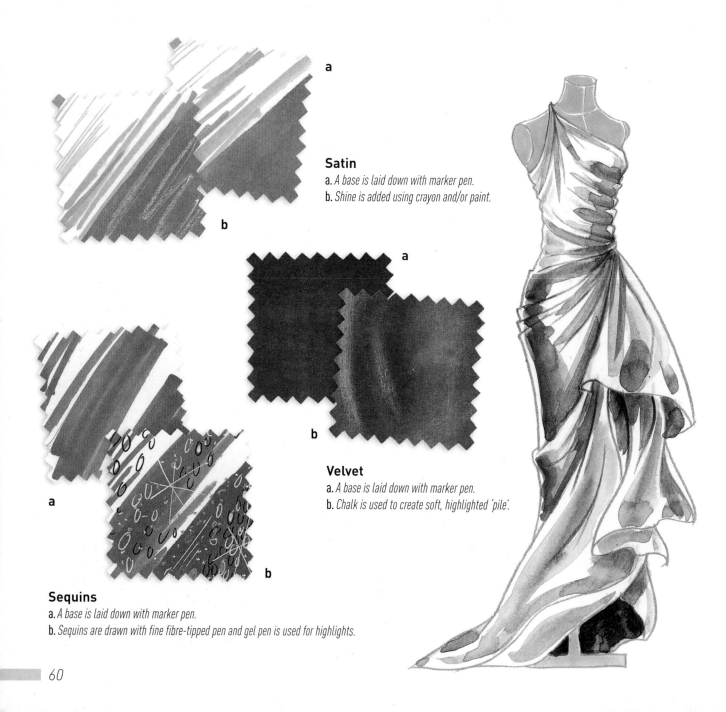

a

Satin
a. *A base is laid down with marker pen.*
b. *Shine is added using crayon and/or paint.*

b

a

b

Velvet
a. *A base is laid down with marker pen.*
b. *Chalk is used to create soft, highlighted 'pile'.*

a

b

Sequins
a. *A base is laid down with marker pen.*
b. *Sequins are drawn with fine fibre-tipped pen and gel pen is used for highlights.*

ANIMAL PATTERNS, FUR AND BROCADE

The loose category of 'animal patterns' covers a range of designs, inspired originally by the markings and textures found on real animal coats. Leopard-skin, cheetah-skin and snakeskin are perennial favourites in the fashion world. New digital printing techniques have resulted in ever-increasing possibilities with regard to the scale of the pattern and repeat. Such has been the popularity of animal prints in recent years that designers are now creating fantasy hybrid patterns that incorporate elements from birds' plumage, patterns found on moths and butterflies, and other variants from the natural world.

Fur, traditionally the skins and coats of dead animals, is used to create very warm garments.

The rarity and/or attractiveness of certain animals once elevated these fabrics to luxury status, but the wearing of real fur is now highly contentious, particularly since modern manufacturing can reproduce convincing synthetic versions.

Brocade is a woven fabric related to satin in terms of the technique used to make it. Patterns are usually created by contrasting areas of raised or floated warp threads against a more simply structured ground. Some variants contrast warp threads against weft threads in a similar way.

This eye-catching coat was drawn with a pencil outline on watercolour paper. Masking fluid was used to create a pattern and watercolour paint was applied.

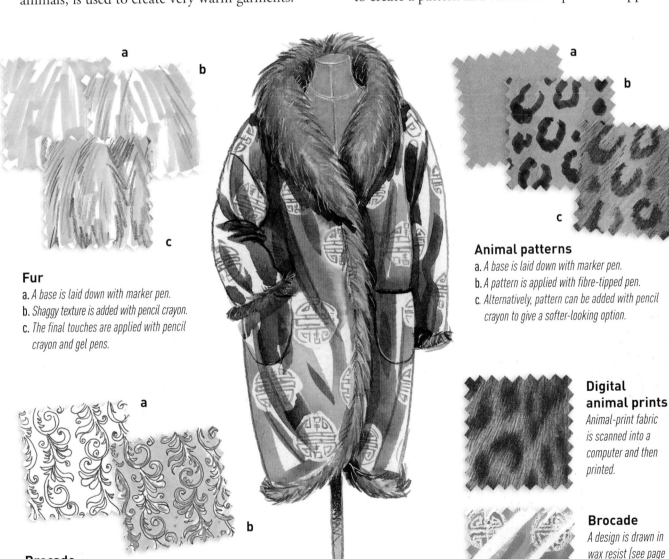

Fur
a. *A base is laid down with marker pen.*
b. *Shaggy texture is added with pencil crayon.*
c. *The final touches are applied with pencil crayon and gel pens.*

Brocade
a. *An outline is drawn with fine fibre-tipped pen.*
b. *The background is filled in with marker pen and gold gel pen is used to add highlights.*

Animal patterns
a. *A base is laid down with marker pen.*
b. *A pattern is applied with fibre-tipped pen.*
c. *Alternatively, pattern can be added with pencil crayon to give a softer-looking option.*

Digital animal prints
Animal-print fabric is scanned into a computer and then printed.

Brocade
A design is drawn in wax resist (see page 57) first, then lightly brushed over with watercolour.

KNIT

Knitting is an ancient method of hand-making fabric and garments that has many cultural roots worldwide, from northern Scotland to Peru and many other countries besides. Most of the knitted patterns such as Fair Isle, Aran or cable which we are familiar with today have origins going back several centuries. Trade and cultural migration has led to many stylistic similarities, resulting in patterns being grouped under a single name, such as 'Nordic', which includes the traditional patterns of Scandinavia, Northern Europe and the Baltic. Since the invention of the earliest knitting machines in the late 16th century for the stocking trade, manufacturers have developed and refined the processes and today machines are able to produce incredibly sophisticated and intricate knitted fabrics and garments. Despite this, perhaps surprisingly, many modern garments are still hand-knitted.

In this men's outfit the soft, warm texture of the Nordic-look sweater is suggested by the subtle colouring, which is applied using marker pens and a little soft pencil crayon for the shadows and the chunky rib trims. The skinny jeans are first rendered with a base of deep blue marker pen, then shadows and highlights are applied with darker and lighter crayons. Fine diagonal pencil crayon marks help to suggest the twill weave of denim.

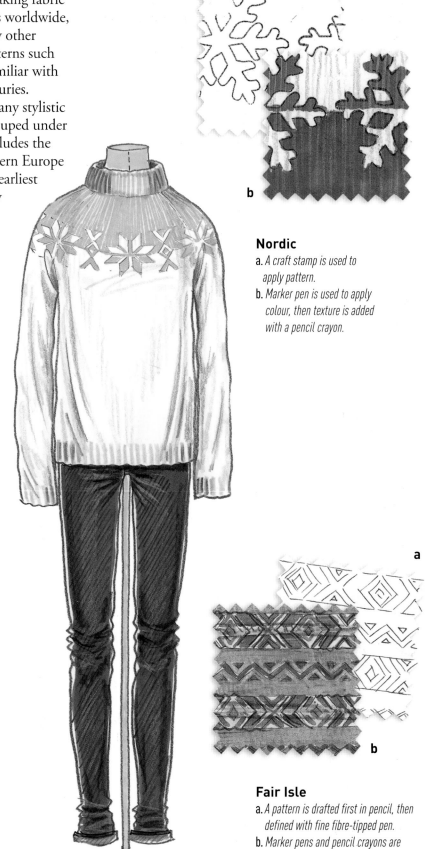

Nordic
a. *A craft stamp is used to apply pattern.*
b. *Marker pen is used to apply colour, then texture is added with a pencil crayon.*

Argyle check
a. *After drafting out a basic pattern in pencil, the diamond shapes are coloured with marker pen.*
b. *Pencil crayon is used to draw in the coloured rakes.*

Fair Isle
a. *A pattern is drafted first in pencil, then defined with fine fibre-tipped pen.*
b. *Marker pens and pencil crayons are used to add texture and depth of colour.*

The young woman's outfit combines a soft, semi-sheer fluted skirt – suggested by using delicate brush pen strokes and light crayoning – and a chunky cable-patterned sweater and a simple knitted scarf, both of which are rendered using controlled and restrained pencil crayon marks.

a

b

c

Nordic
a. *A pattern is first drafted out in pencil.*
b. *Marker pen adds delicate colour and the pencil marks are erased.*
c. *Texture and depth of colour are rendered using pencil crayon.*

a

b

Textured stitches
a. *A pattern is mapped out in pencil, if possible using a real stitch reference for accuracy and clarity.*
b. *The pattern is defined with marker pen, then the pencil is erased. Texture and depth of colour are applied with pencil crayon.*

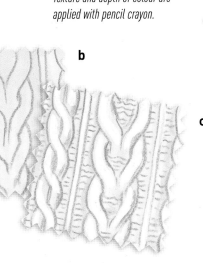

a

b

Cable and Aran stitches
a. *A base colour is applied with marker pen.*
b. *A pattern is carefully mapped out in pencil crayon.*
c. *Shading and definition are applied with toning pencil crayons.*

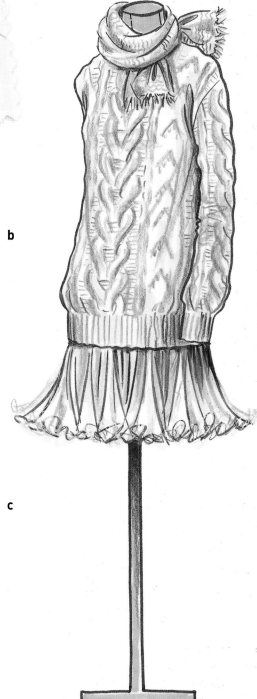

a

b

c

HARD-WEARING FABRIC

Leather
Marker pen is used to create variations of tone.

Distressed leather
An oil pastel rubbing on a rough surface creates a distressed effect.

Leather has two principal qualities that fashion perpetually exploits and celebrates: the first is luxury – the depth of colour, supple feel of the fabric and the craftsmanship associated with handling this relatively difficult material; and the second is (perhaps conversely) its tough rebel image, which has its origins in the youth movements of the late 1950s, 60s and 70s, and which is somehow enhanced by signs of wear and tear.

Canvas and denim are tough, relatively coarse-grain fabrics, which have their origins in utility wear. One of the most-loved qualities of denim is the way in which it fades and wears, a quality we associate with individuality and a certain rebel spirit, although much of the denim we buy today is already faded.

Twill is a type of textile weave that repeats on three or more ends or 'picks', which produces the diagonal grain that is characteristic of twill fabric.

For this cool biker girl look, the jeans are again rendered with a base of deep blue marker pen with shadows and highlights applied with darker and lighter crayons. Fine diagonal pencil crayon marks suggest the twill weave of denim, and there are pronounced faded effects as well as delicately drawn and shaded rips and holes. By only partially colouring the jacket, the effect of shine and highlights on softly worn leather is created. Marker pen and a little correction fluid are used to finish a sparkly singlet.

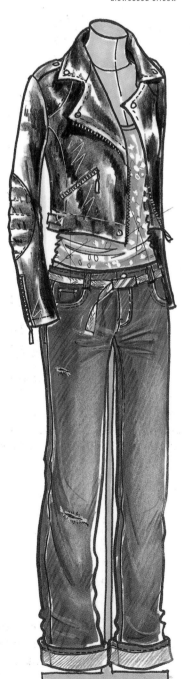

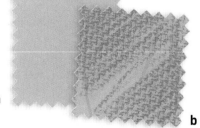

Canvas
a. *A base is applied with marker pen.*
b. *An oil pastel rubbing creates texture.*

Twill
a. *A base is applied with marker pen.*
b. *A rubbing using marker pen produces a textured finish.*

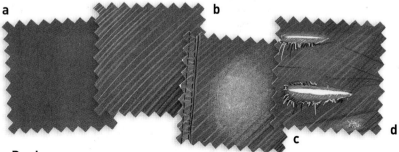

Denim
a. *A base is applied with marker pen.*
b. *Diagonal twill lines are added with pencil crayon.*
c. *Stitching is rendered with black fibre-tipped pen and worn areas with pastel crayon.*
d. *Pastel crayon and white gel pen are used to add rips.*

The idea of camouflage was first understood by hunters, who took their inspiration from the animals they pursued and their habitats. Although the notion was taken up by the military in the 18th century, it did not really develop into the wide range of specialist fabric patterns we know and recognize today until the First and Second World Wars.

Felt is a dense, textured fabric, the surface of which is compacted and flattened during the manufacturing process to make it very hardwearing.

Corduroy is a woven fabric not dissimilar to velvet in its construction, with a cut weft pile. The vertical lines of the pile, running parallel to the warp, are known as 'wales', as indeed are the vertical lines of rib structures in knitting.

This figure's dark reefer or pea coat could have been flat and lifeless, but deliberately leaving exposed white ground and further highlighting the seams and structure in white pen gave it clarity and definition. The twisted and loosely wrapped striped scarf has been well observed and translated. A base has been applied with marker pen and bold chinagraph pencil lines are used to create the look of soft chunky cord trousers.

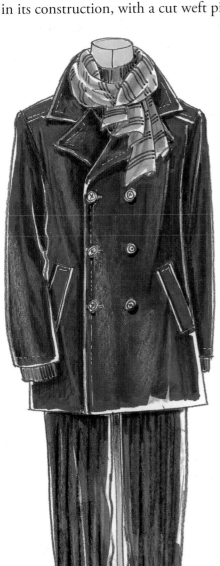

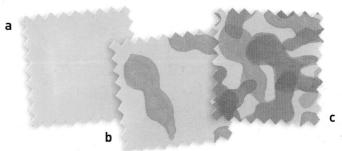

Camouflage

a. *A base is applied with marker pen.*
b. *A pattern is added with another shade of marker pen.*
c. *More overlapping marker pen shapes are layered to create the desired effect.*

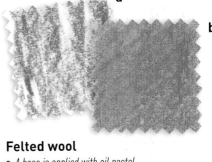

Felted wool

a. *A base is applied with oil pastel.*
b. *A second tone in oil pastel is blended with white spirit, then another rough layer of oil pastel is added on top.*

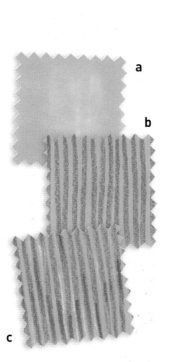

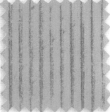

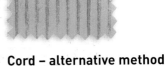

Needle cord and jumbo cord

a. *A base colour is applied with marker pen.*
b. *Vertical strokes in oil pastel indicate the texture.*
c. *White pencil crayon is used to add highlights.*

Cord – alternative method

A base colour is applied with marker pen, then a rubbing on a ribbed surface is made using oil pastel.

MENSWEAR FABRIC

Tweed, originally a heavyweight woollen fabric used for outerwear, was traditionally woven in southern Scotland. The name is taken from the River Tweed, the water of which was used to wash and finish the fabric. Today the term tweed applies to a wide range of wool, wool blends and look-alike fabrics. One of its principal attractions, aside from its practicality, is the mix of pleasing colours that are made possible by the dying and weaving techniques used. Donegal in Ireland lends its name to a speckled, napped,

tweed-type fabric that was unique to the area.

The quality of the drawing below and the successful rendering of the fabrics have been greatly helped by the choice of lovely grainy Ingres paper. The tweed jacket is created with a marker pen base to which oil pastel shadowing and flecks of colour using soft crayon have been added. The pinstripe fabric of the trousers is rendered with a rough background of marker pen to which vertical lines have been applied using white pen.

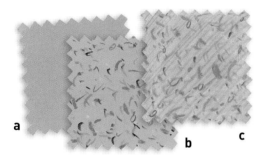

Donegal tweed
a. *A base is applied with marker pen.*
b. *Random dots are added with pencil crayon and pastel.*
c. *The impression of neps (small balls of fibre on the surface of a fabric) and texture is created with pencil crayon.*

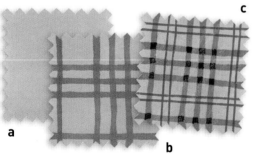

Heritage check
a. *A base is applied with marker pen.*
b. *Check lines are added with marker pen.*
c. *Pencil crayon is used for overlaid check lines.*

Shepherd's check
(and gingham-type structured fabrics)
a. *With a pencilled grid as a guide, diagonal lines are used to create two vertical columns in fibre-tipped pen.*
b. *Horizontal columns of diagonal lines are added to create a check.*
c. *The crossover points of the columns are emphasized by colouring in these areas more solidly.*
d. *The check size can be varied by changing the width of the columns and their distance apart.*

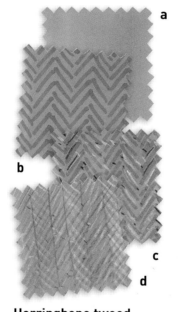

Herringbone tweed
a. *A base is applied with marker pen.*
b. *The basic herringbone structure is added with marker pen.*
c. *Pencil crayon is used to add highlights and tweed effects.*
d. *An alternative technique is to use pencil crayon to mark the pattern on to the marker pen base (see Soft Muted Herringbone on facing page).*

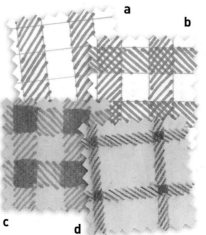

e term herringbone describes a traditional woven ttern, created using a twill (diagonal) weave that reversed after several courses to produce stripes embling herringbones.

Shepherd's check is created in contrasting colours grouping four, six or eight threads of two colours d using a twill weave. The name probably iginated from the plaids worn by shepherds in the lls of the Scottish Borders. Houndstooth or gstooth are variations of this weave. Many of the nting estates of the British aristocracy developed eir own characteristic check colours and patterns

that have become known collectively as estate tweeds, or sometimes as estate or heritage checks.

Gingham is a plain weave cotton fabric in which a square construction of dyed yarns is contrasted against white or undyed yarns to form small checks.

On this page, deft lines of marker pen create the ribbed roll-neck sweater. For the overcoat, marker pen was used for the base, with the herringbone pattern completed in fine fibre-tipped pen. White gel pen was used for highlights and lowlights. The trousers were drawn with a base of marker pen, with crayon used for the shadows and highlights.

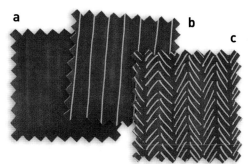

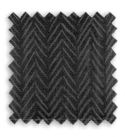

Pinstripe and fine herringbone

a. *A dark base is applied with marker pen.*
b. *The pin stripe is drawn with white gel pen.*
c. *The herringbone pattern is drawn with gel pen for a fine, crisp effect.*

Soft muted herringbone

This tweed version of the herringbone pattern is drawn using soft pencil crayon over a dark marker pen base.

Prince of Wales check

a. *A base is applied with marker pen.*
b. *Bands of vertical lines are added with fine fibre-tipped pen.*
c. *Bands of horizontal lines are similarly added using fine fibre-tipped pen, and pencil crayon over the top adds texture and depth.*

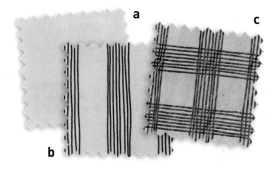

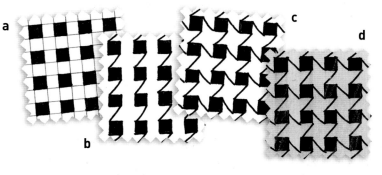

Houndstooth check *(a smaller-scale version of the check is sometimes called puppytooth)*
a. *Using a grid drawn on in pencil, squares are marked out as shown with marker pen.*
b. *The grid is erased and diagonal lines are added to link the boxes vertically using fine fibre-tipped pen.*
c. *Lateral diagonal lines link the boxes horizontally.*

PRINTS

Printing is a way of creating pattern on fabric after it has been woven. Fabric has been printed by various cultures throughout the world for thousands of years. The invention of roller printing at the end of the 18th century revolutionized the process and made patterned fabrics affordable for almost everyone. Modern digital printing processes are again changing the industry, solving problems that have until now restricted the number of colours it is possible to print and the scale of the patterns' repeats.

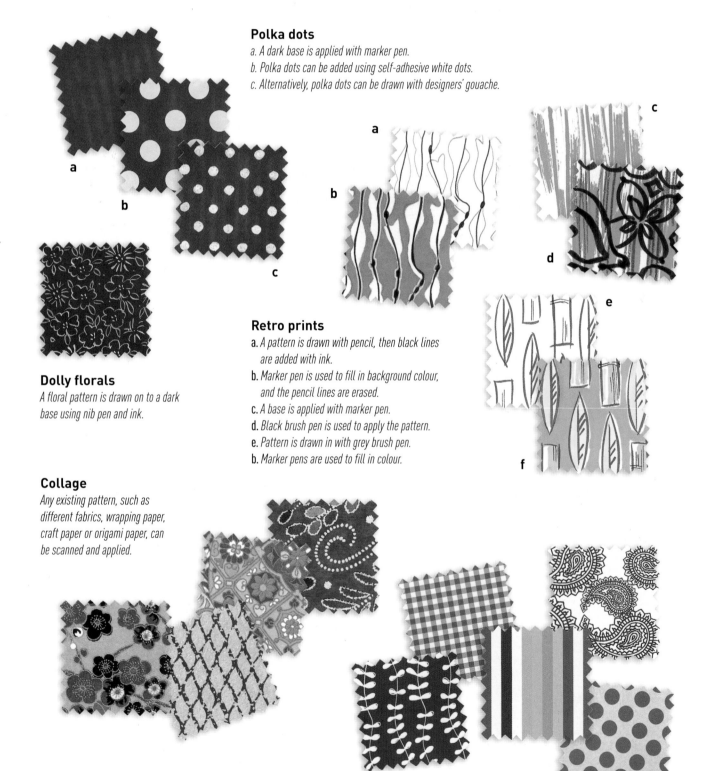

Polka dots
a. A dark base is applied with marker pen.
b. Polka dots can be added using self-adhesive white dots.
c. Alternatively, polka dots can be drawn with designers' gouache.

Dolly florals
A floral pattern is drawn on to a dark base using nib pen and ink.

Retro prints
a. A pattern is drawn with pencil, then black lines are added with ink.
b. Marker pen is used to fill in background colour, and the pencil lines are erased.
c. A base is applied with marker pen.
d. Black brush pen is used to apply the pattern.
e. Pattern is drawn in with grey brush pen.
b. Marker pens are used to fill in colour.

Collage
Any existing pattern, such as different fabrics, wrapping paper, craft paper or origami paper, can be scanned and applied.

Cotton fabric is woven from cotton fibre, which forms in a boll (protective capsule) around the seeds of a species of plants of the genus *Gossypium* and is unravelled and treated to form the long strands that are used for making fabric. It is grown in many regions of the world, and the cotton fibres vary from country to country, with each having their own particular qualities and advantages. Egyptian cotton plants, for example, produce very long fibres that are woven to create one of the finest cotton fabrics, which is used for making high-quality shirts and fine bed linen. Patterned cotton falls into two distinct categories; woven and printed. Woven patterns include variations of stripes and checks that are created by using contrasting colours of thread in the warp and weft. Printed patterns cover almost every other type of pattern possible.

This floral dress was drawn using a soft pencil outline on watercolour paper. Pattern and some light shadows were added in watercolour. Pencil crayon was used for shading and definition.

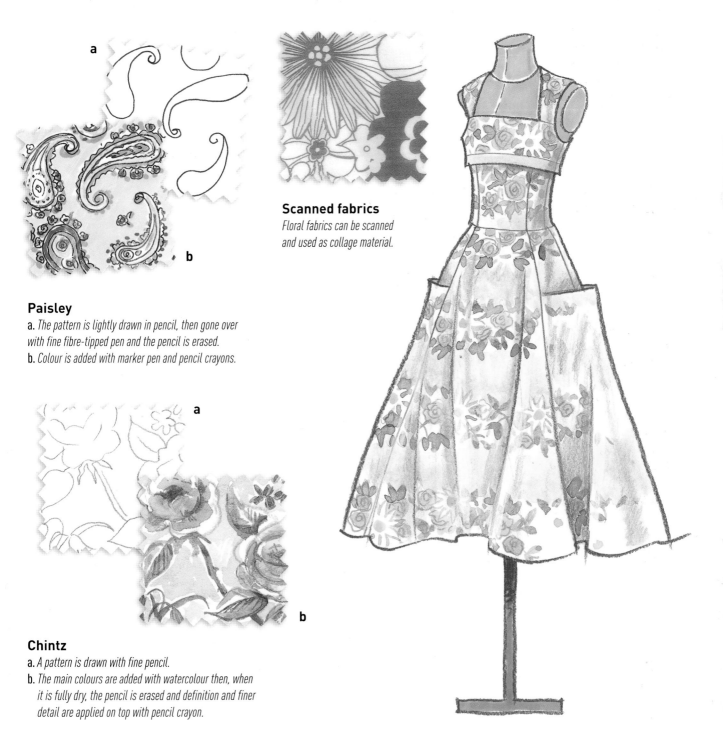

Scanned fabrics
Floral fabrics can be scanned and used as collage material.

Paisley
a. *The pattern is lightly drawn in pencil, then gone over with fine fibre-tipped pen and the pencil is erased.*
b. *Colour is added with marker pen and pencil crayons.*

Chintz
a. *A pattern is drawn with fine pencil.*
b. *The main colours are added with watercolour then, when it is fully dry, the pencil is erased and definition and finer detail are applied on top with pencil crayon.*

DRAWING GARMENTS AND OUTFITS

With a broader knowledge of fabrics – their qualities, characteristics and behaviour – and a better understanding and appreciation of garment details and construction you can approach the challenge of fashion drawing with confidence. So it follows that the next essential step is to learn something about the construction of clothes, including details such as how a shirt collar works and sits around a neckline, how a jacket rever or lapel folds and rolls, and how shirt cuffs and plackets, pockets, epaulettes, gathers, pleats and so on function. Similarly, you will draw a silhouette better if you understand how the outline is achieved – where the volume comes from and how it is suppressed, reduced or controlled.

You can obtain much of this information simply by paying attention to clothes and studying them with a critical eye, either at home or in stores. Ask questions such as: what is happening here, how is that shape created, how does that neckline or fastening work? There is nothing to stop you trying something on in a store, or asking a friend of the opposite gender to try it on for you, so you can better understand the subtleties and complexities of the construction. Take a closer look and turn the garment inside out, if necessary in the privacy of the changing room. Good drawing comes from good seeing. When it comes to designing, part of the function of drawing is about communicating how the garment is constructed and resolving any issues in order that it can be realized successfully.

Remember, although you may be trying to draw an idea, something new out of your head, there is always something to hand to help you to understand how to draw that notion, be it a real garment with a similar feature or the reference material you have gathered in your scrapbook – your collection of found images, magazine tears, museum and costume drawings and so on. Even draping some fabric in similar fashion across a dress stand or yourself in front of a mirror can assist your imagination and help you to explain and communicate your ideas in your sketches. Keep trying out different variations until you hit upon an illustration that works – ideas evolve as they are drawn and different possibilities present themselves with each adaptation. Above all, have fun!

URBAN GIRL

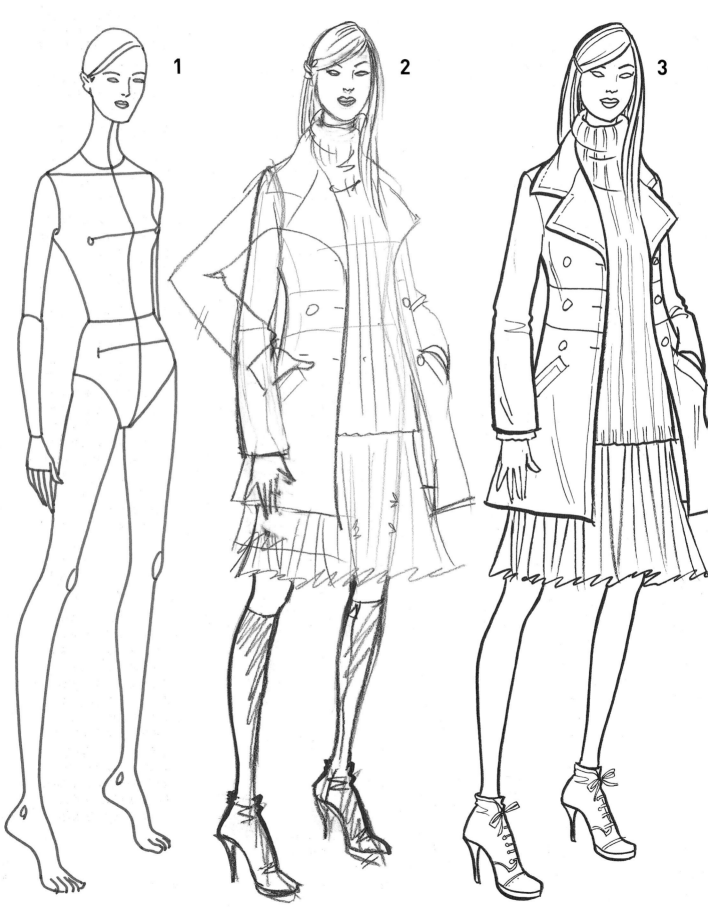

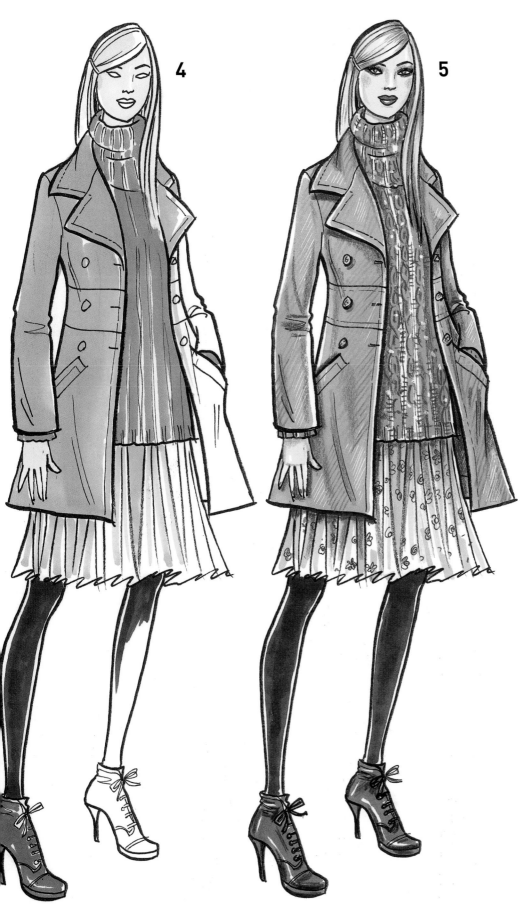

1. *Trace a model from your template, amending limb positions as required.*

2. *Plot out the silhouette of the outfit and the positioning of main details, such as the depth and angle of the neckline and collar. Use a light pencil mark that can be easily erased and altered. Still using pencil, lightly add the hairstyle, facial features and accessories. Remember the clothes should be drawn slightly larger than the figure itself so they look realistic and not skin tight.*

3. *Once you are happy that everything looks right, ink in the outlines and strongest details with a medium-thickness fibre-tipped pen or a brush pen. Erase the pencil marks.*

4. *Having completed the outline you can add colour using marker pens, watercolour – which produces a more fluid appearance and enables you to mix your own shades – or oil pastel crayons, which give a softer blurred look. Marker pens are ideal for adding skin tones at this stage. Best results are often achieved by not taking the colour right to the edges of the outlines; completely coloured-in drawings can seem very flat and lifeless. Using a marker pen in quick, light directional strokes also helps to enhance the appearance of the pleats in the skirt and gives the effect of movement.*

5. *Add fine fabric details such as texture and print with pencil crayons and wax crayons. Add a little shadowing to help enhance the layering effects and give a more 3D look to collars, pockets and so on. You might want to emphasize topstitching or add shine at the edge of a button. Using white pencil crayon on medium to dark fabrics can help to add definition. Make-up has been added to the face and highlights to the hair.*

VACATION GIRL

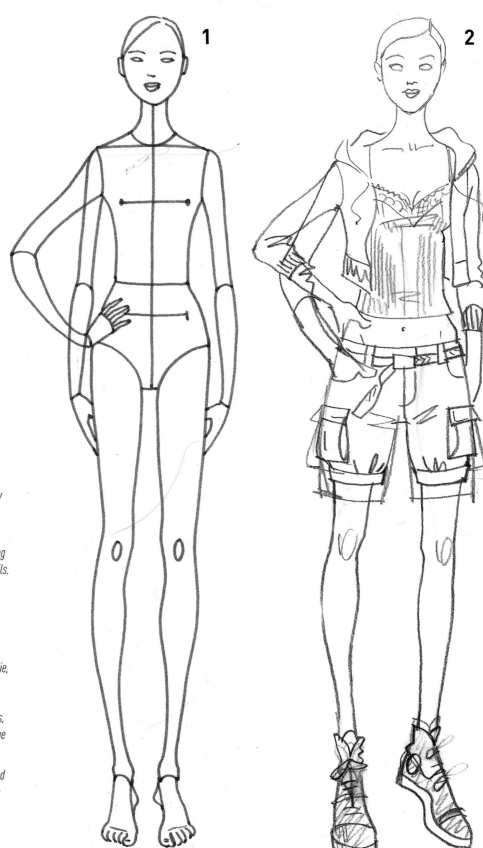

1. Choose your template and make any minor adjustments to the pose.

2. Draw the whole outfit in pencil, checking the proportions and making any final decisions about finer details.

3. Once you are satisfied, ink in the outlines using brush pen and fine fibre-tipped pens, then erase the pencil marks.

4. Use marker pens to colour the hoodie, camouflage print, skin tones and hair. Leave small areas of white paper showing to suggest highlights, which help to add depth and stop the drawing looking too flat.

5. Delicate lines of colour can be added to suggest a rib jersey fabric for the camisole. Use soft pencil and wax crayon for finer details and shading.

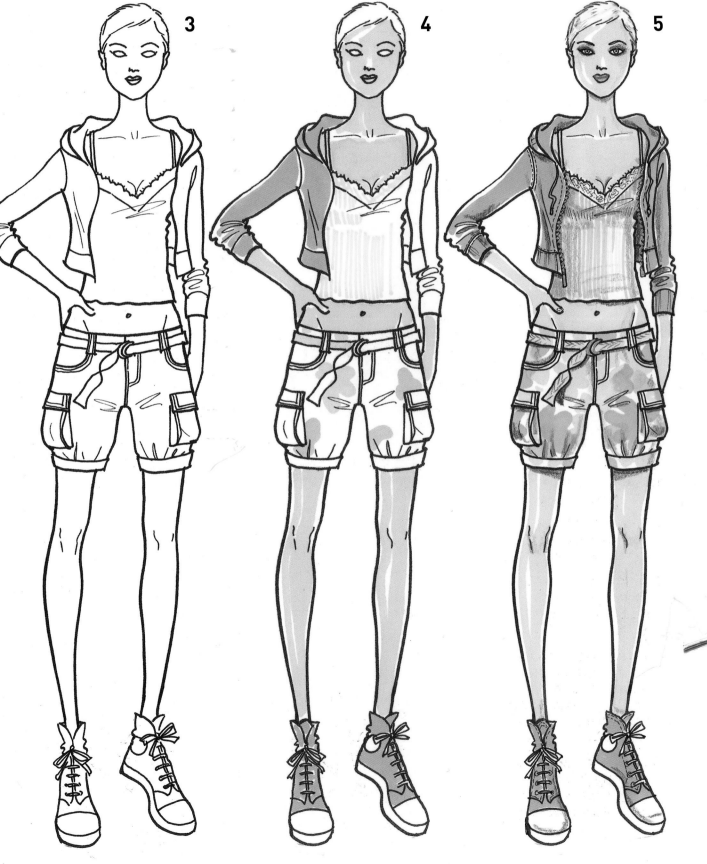

PARTY GIRL

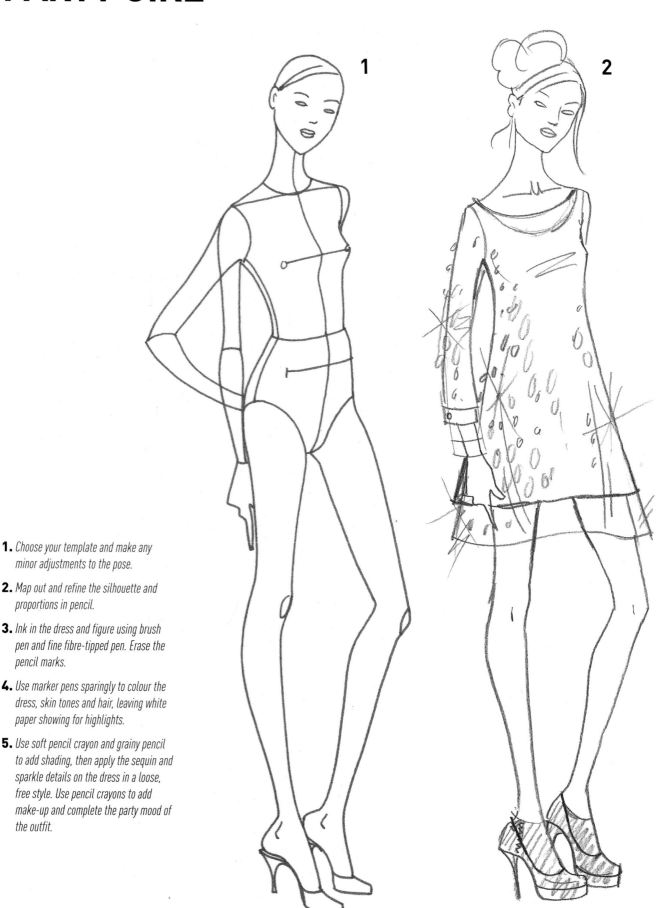

1. *Choose your template and make any minor adjustments to the pose.*

2. *Map out and refine the silhouette and proportions in pencil.*

3. *Ink in the dress and figure using brush pen and fine fibre-tipped pen. Erase the pencil marks.*

4. *Use marker pens sparingly to colour the dress, skin tones and hair, leaving white paper showing for highlights.*

5. *Use soft pencil crayon and grainy pencil to add shading, then apply the sequin and sparkle details on the dress in a loose, free style. Use pencil crayons to add make-up and complete the party mood of the outfit.*

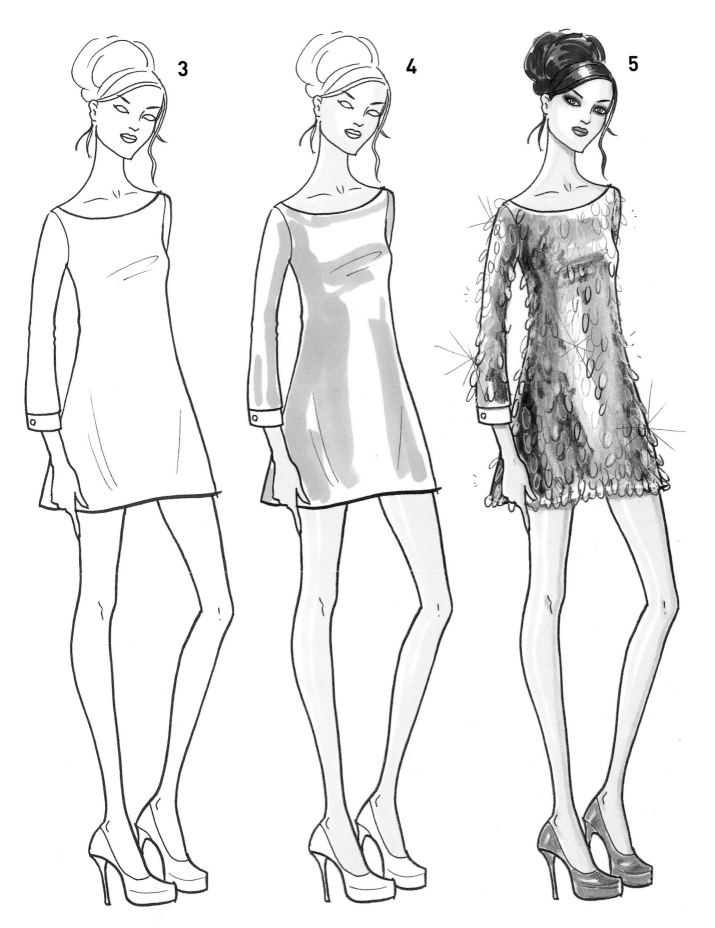

URBAN GUY

1. *Choose your template and make any minor adjustments to the pose.*

2. *Draw the whole outfit in pencil, checking the proportions and making final decisions about details.*

3. *Once you are satisfied, use a brush pen and fine fibre-tipped pens to finalize the outlines, structure and details. Note how small broken lines are used here to suggest the fleece/pile fabric of the hood lining.*

4. *Use light coloured pencil strokes to indicate the relatively complex patterning of the jacquard Nordic-look sweater. Marker pens are best for blocking in base colours for the jeans and roll-neck sweater.*

5. *Continue adding delicate marks with fine fibre-tipped pen to build up the sweater's pattern, keeping the pattern loose and not too defined to indicate a soft, wool-like feel rather than a flat printed look. Use a pencil crayon to add soft shading and highlights to the sweater and jeans. Apply additional diagonal strokes of pencil crayon to the jeans to depict a grainy denim look.*

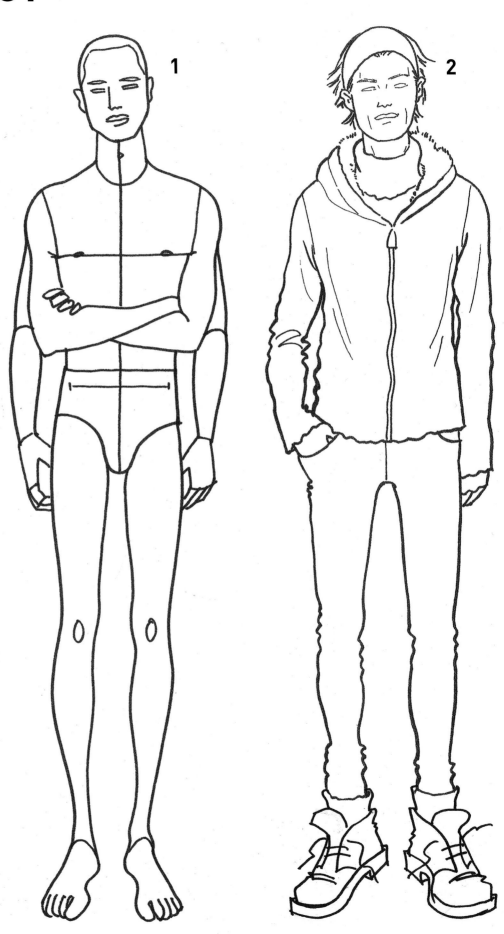

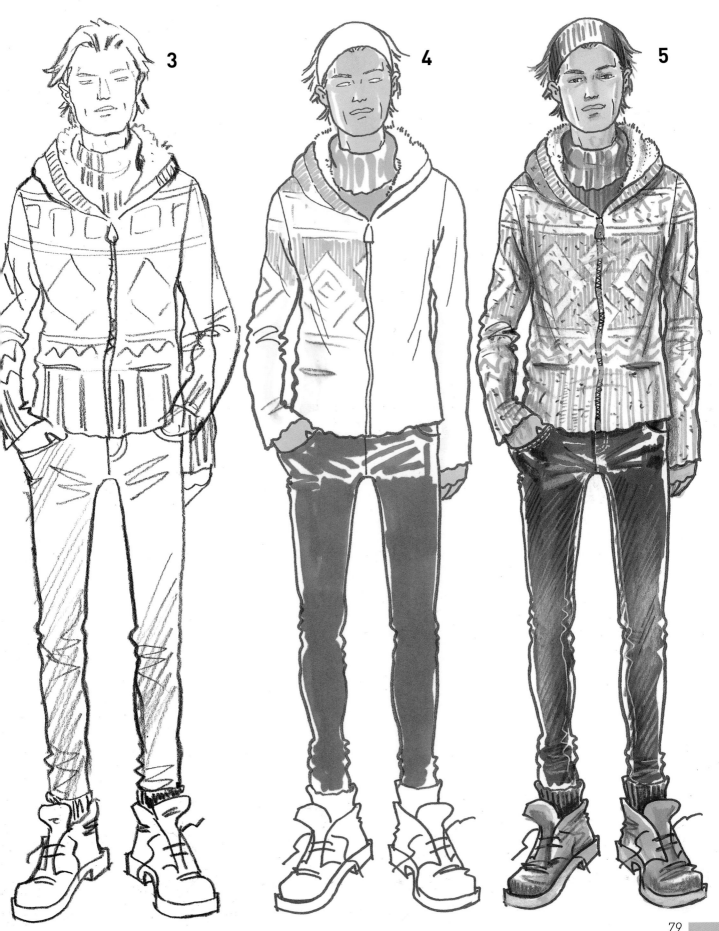

VACATION GUY

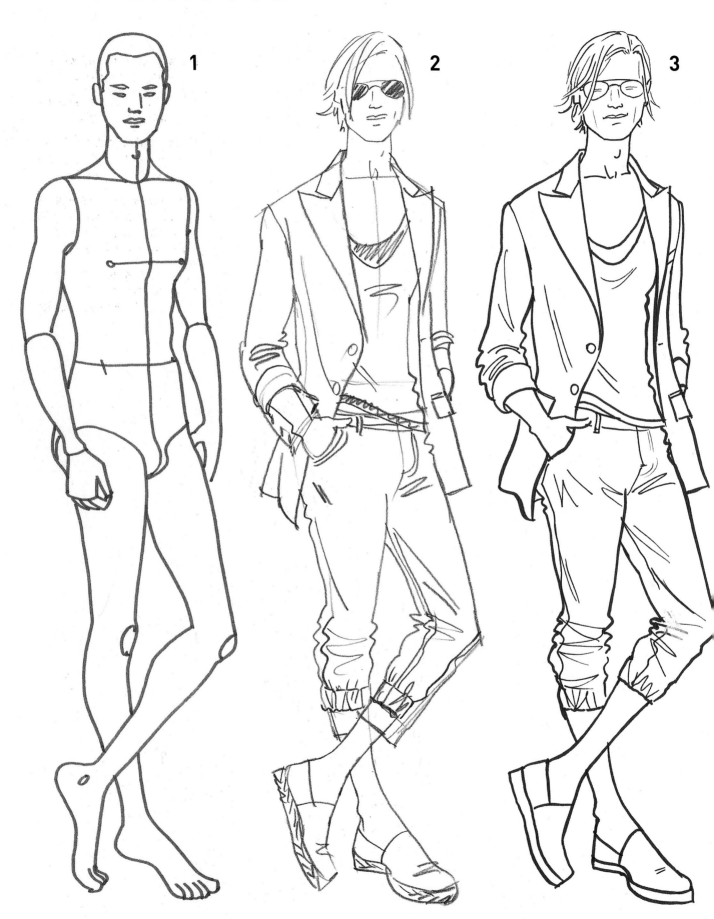

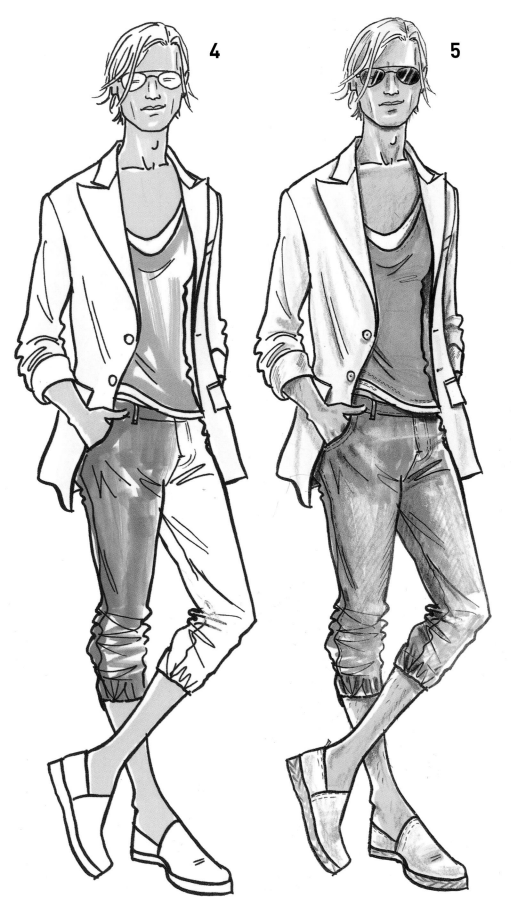

4

5

1. *Choose your template and make any minor adjustments to the pose.*

2. *Using pencil, sketch out the silhouette, proportions and finer details.*

3. *Ink in the outline, garments and features with a brush pen and fine fibre-tipped pens. Erase the pencil marks.*

4. *Add ground colour using marker pens, leaving areas of white paper showing to add depth and for highlights. Add finer details with fine fibre-tipped pens.*

5. *Using pencil crayons, add shadows and highlights as required, and use diagonal strokes to create a grain effect on the denim.*

PARTY GUY

1. *Choose your template and make any minor adjustments to the pose.*

2. *Using pencil, sketch out the basic fit, proportions and details of the garments and accessories.*

3. *Use brush pen and fine fibre-tipped pen to ink in the outlines and details, then erase the pencil marks.*

4. *Use marker pens to add colour. Black fabric is always hard to draw, and although marker pens give a good density of colour you must be sure to leave a little more white paper showing than you might at first think necessary, or the garment could look lifeless and flat. Add ground colour only for the trousers at this stage.*

5. *Add the check detail to the trousers using light, controlled pencil crayon strokes; you are aiming to merely give a hint of the pattern. Use marker pens for accessories, hair and skin tones, and correction pen to lend a crisp clarity to the polka-dotted bow tie.*

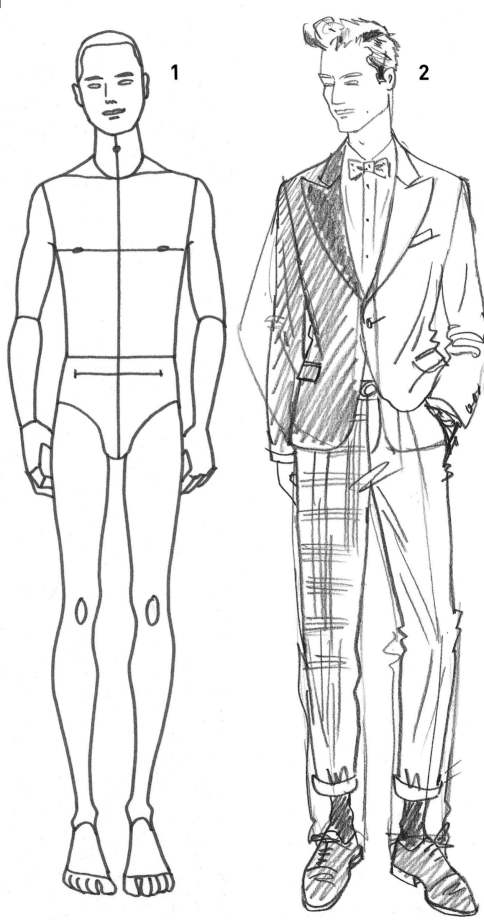

CHAPTER 6

DRAWING AND DESIGNING USING A TEMPLATE

As we have seen in Chapter 5, using a template when illustrating clothes is a great help. Similarly, a template can be a valuable work-in-progress tool for designing clothes, helping to make the creative process more speedy and efficient. By adapting a template that reflects the demographic of your customer in terms of size and proportion you will be able to best portray your designs in an appropriate way.

In addition to figure templates, designers also use templates for drawing 'flats', which are the outlines of garments, rather than figures, that are given to manufacturers when making clothes. Used in a similar way to a figure template, a flat template can be placed under a sheet of paper and quickly traced in order to ensure that the scale and proportion of a range of drawings of the same item are uniform. This makes assessing and comparing the designs much easier.

More detailed flats are commonly termed 'technical drawings', and focus on particular features such as lapels, necklines, drapery and stitching, providing in-depth and accurate guidelines that will ensure the garment is made correctly. Information about the fabric to be used must also be conveyed, whether by being drawn, collaged or scanned, and it is essential that the flow and overall feel of the material are depicted in the illustration. In addition to using traditional methods for creating flats, many modern designers use CAD (Computer Aided Design), which produces very accurate renderings of the garments.

FLATS AND FLOATS

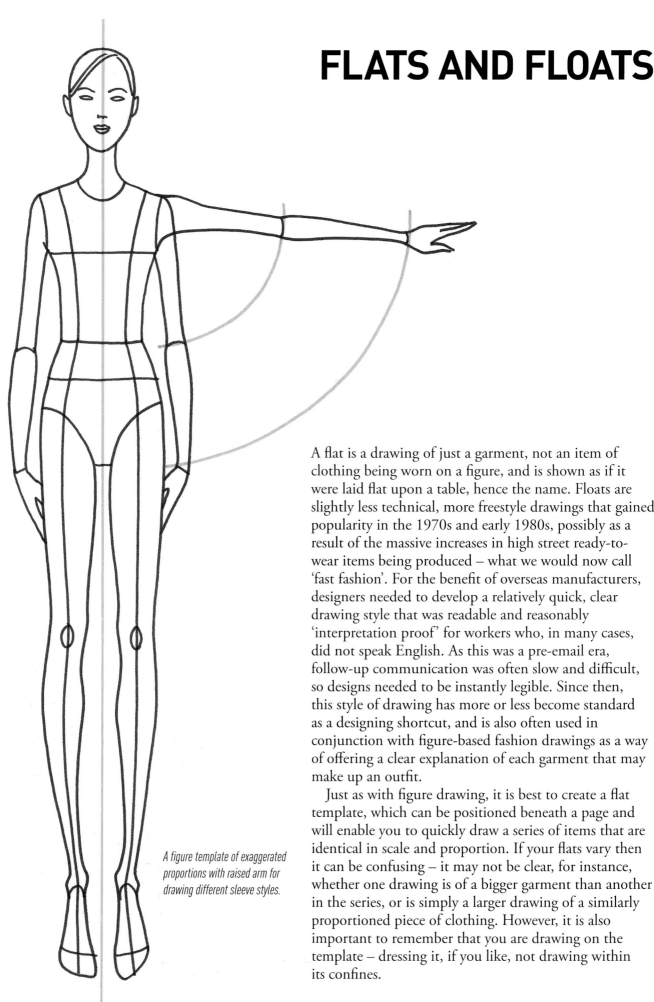

A figure template of exaggerated proportions with raised arm for drawing different sleeve styles.

A flat is a drawing of just a garment, not an item of clothing being worn on a figure, and is shown as if it were laid flat upon a table, hence the name. Floats are slightly less technical, more freestyle drawings that gained popularity in the 1970s and early 1980s, possibly as a result of the massive increases in high street ready-to-wear items being produced – what we would now call 'fast fashion'. For the benefit of overseas manufacturers, designers needed to develop a relatively quick, clear drawing style that was readable and reasonably 'interpretation proof' for workers who, in many cases, did not speak English. As this was a pre-email era, follow-up communication was often slow and difficult, so designs needed to be instantly legible. Since then, this style of drawing has more or less become standard as a designing shortcut, and is also often used in conjunction with figure-based fashion drawings as a way of offering a clear explanation of each garment that may make up an outfit.

Just as with figure drawing, it is best to create a flat template, which can be positioned beneath a page and will enable you to quickly draw a series of items that are identical in scale and proportion. If your flats vary then it can be confusing – it may not be clear, for instance, whether one drawing is of a bigger garment than another in the series, or is simply a larger drawing of a similarly proportioned piece of clothing. However, it is also important to remember that you are drawing on the template – dressing it, if you like, not drawing within its confines.

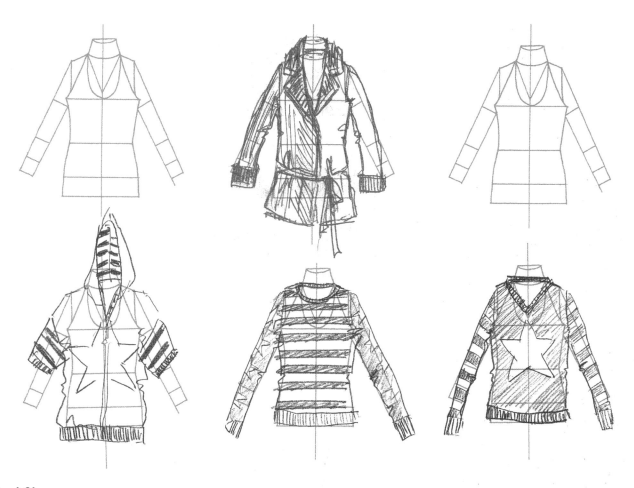

Noel Chapman
Small design roughs using a template.

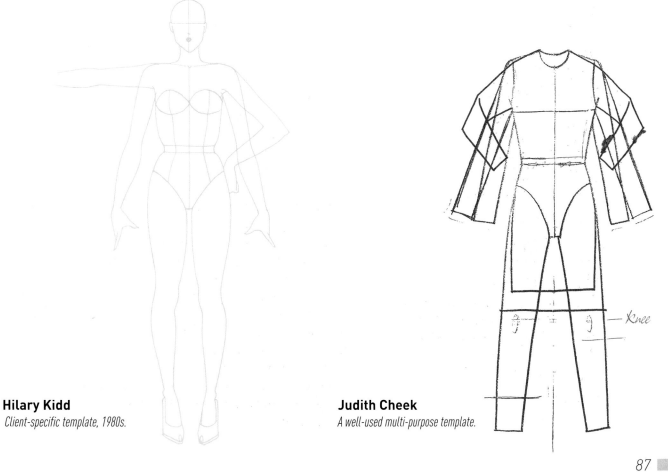

Hilary Kidd
Client-specific template, 1980s.

Judith Cheek
A well-used multi-purpose template.

CREATING A TEMPLATE FOR FLATS

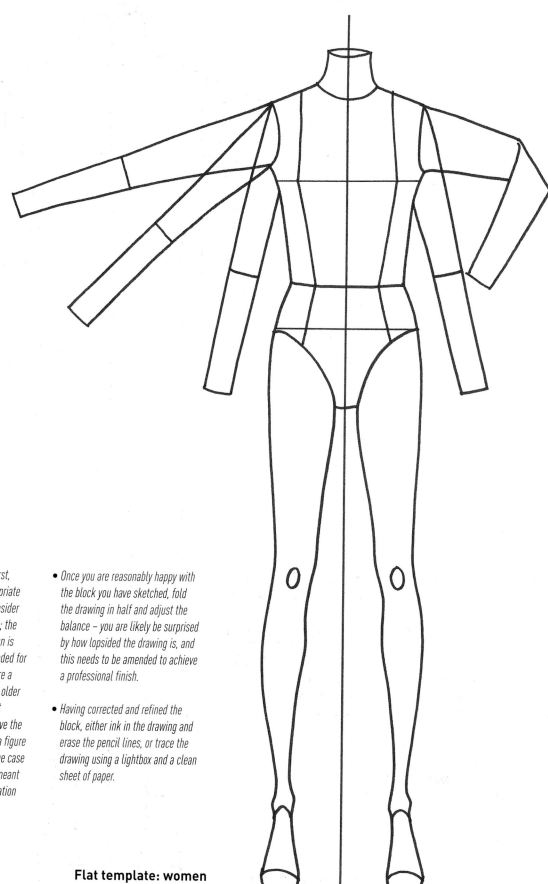

- *To create a flat template, first, using pencil, draft an appropriate body 'block'. You should consider the end use of your drawing; the target market for your design is important and designs intended for a younger market will require a different block to that of an older or more classic market. Flat templates do not usually have the exaggerated proportions of a figure template as, especially in the case of technical flats, they are meant to be an accurate representation of a garment.*

- *Once you are reasonably happy with the block you have sketched, fold the drawing in half and adjust the balance – you are likely be surprised by how lopsided the drawing is, and this needs to be amended to achieve a professional finish.*

- *Having corrected and refined the block, either ink in the drawing and erase the pencil lines, or trace the drawing using a lightbox and a clean sheet of paper.*

Flat template: women

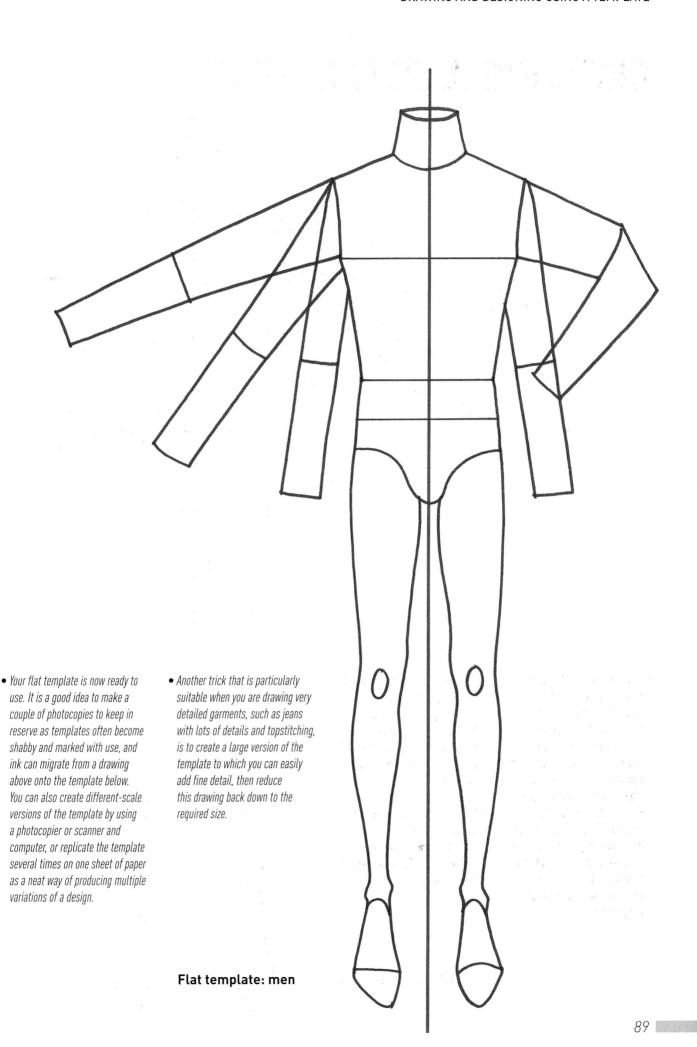

- *Your flat template is now ready to use. It is a good idea to make a couple of photocopies to keep in reserve as templates often become shabby and marked with use, and ink can migrate from a drawing above onto the template below. You can also create different-scale versions of the template by using a photocopier or scanner and computer, or replicate the template several times on one sheet of paper as a neat way of producing multiple variations of a design.*

- *Another trick that is particularly suitable when you are drawing very detailed garments, such as jeans with lots of details and topstitching, is to create a large version of the template to which you can easily add fine detail, then reduce this drawing back down to the required size.*

Flat template: men

FLATS: EXAMPLES

You should use a range of pens of different thickness for all types of flats, floats and technical drawings, both for clarity and to avoid monotony. Thicker-line pens will help to define outer edges, flaps and openings, while finer-line pens should be used for top-stitching. Brush pens can help to add a little additional movement and energy to floats and are also helpful when drawing fine and delicate fabrics.

Although primarily a functional drawing, one should not forget that a flat or float still needs to be attractive; it has to look convincing and communicate and sell the design, so keep looking and assessing its appeal and apparent accuracy.

Women's trenchcoat
Outline: *0.8 mm fibre-tipped pen*
Seams: *0.3 mm fibre-tipped pen*
Pockets and lapels: *0.5 mm fibre-tipped pen*
Top-stitching: *0.05 mm fibre-tipped pen.*

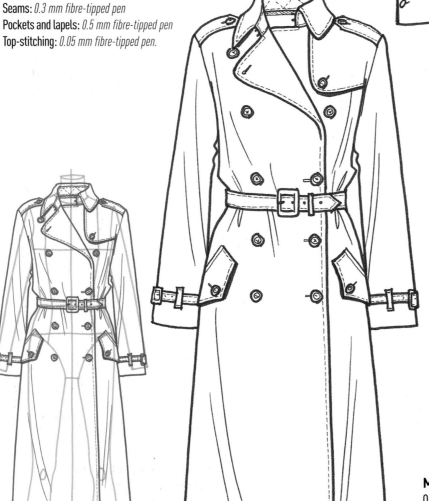

Men's suit
Outline: *0.8 mm fibre-tipped pen*
Seams and pockets: *0.5 mm and 0.3 mm fibre-tipped pen*
Stab-stitching: *0.05 mm fibre-tipped pen.*

Menswear t-shirt
Outline: *0.8 mm fibre-tipped pen*
Seams and neckline: *0.5 mm fibre-tipped pen*
Logo/numbers: *0.3 mm fibre-tipped pen. An additional tip here is to print out your logo or numbers from a computer, experimenting with scale and font size until you get something that works for the drawing's scale and look.*
Top-stitching: *0.05 mm fibre-tipped pen.*

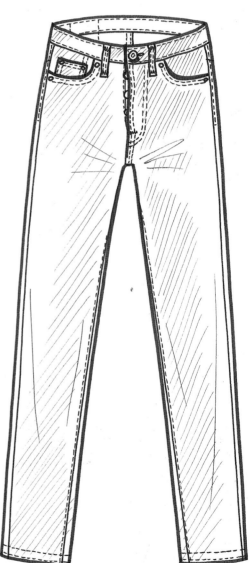

Women's halterneck
Outline: *Brush pen*
Stitching: *0.05 mm fibre-tipped pen*
Inside shadow: *0.05 mm fibre-tipped pen. For this type of garment, shadow is required to make the drawing easier to read.*

Classic five-pocket jeans
Outline: *0.8 mm fibre-tipped pen*
Seams: *0.3 mm fibre-tipped pen*
Top-stitching: *0.1 mm fibre-tipped pen*
Denim indication (twill): *0.05 mm fibre-tipped pen.*

TECHNICAL DRAWINGS

The purpose of a technical drawing is to communicate exactly how to make an item of clothing. Whether it is you or a third party who will make the garment, it is down to the designer to analyse and problem-solve at this stage. A technical drawing is a detailed, disciplined (tight), flat drawing that includes all the essential measurements. It may be necessary to provide additional close-up drawings of particularly complicated details such as pockets and collars that require further explanation.

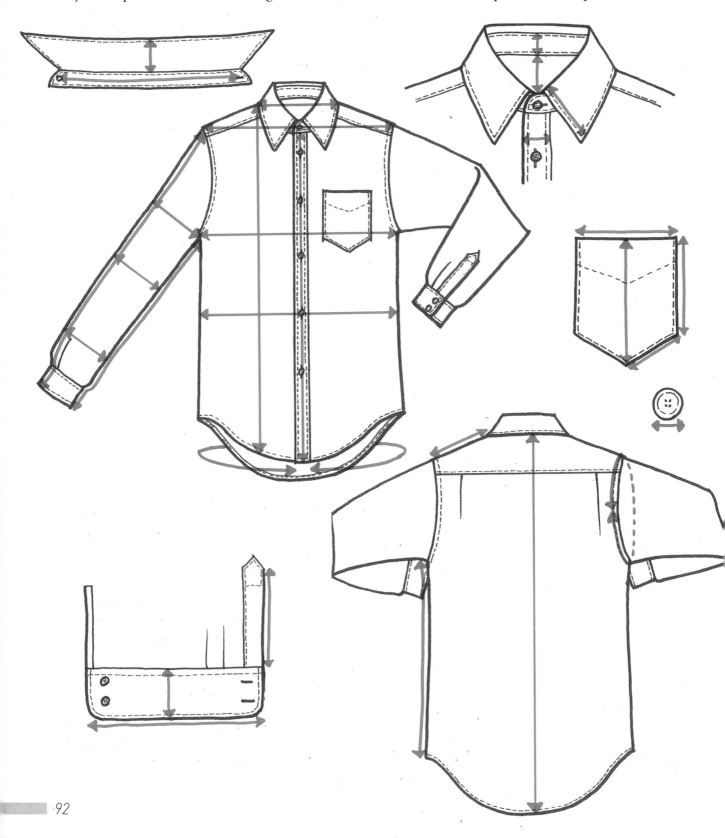

GETTING THE STYLE AND DETAILS RIGHT – MENSWEAR COLLARS AND LAPELS

There are countless styles of shirt collar for both men and women. Influenced by fashion trends, the variations are often simply subtle nuances of line, which over the course of time cause even so-called classics to evolve. However, all originate from half a dozen or so basic designs. These may be subdivided into two main categories: one-piece collars, which are cut from a single piece of fabric and do not have a separate stand; and two-piece collars, which comprise a separate collar and stand.

A collarless top – sometimes called a 'granddad shirt', or a garment with a 'granddad collar' or 'stand collar' – is a shirt that has a collar stand without a collar attached. It originates from the days when formal, starchy collars were made separately and affixed and removed as required, making the shirt easier to launder. It also prolonged the life of the shirt as the collars could be simply replaced when they wore out. The Mao and Nehru collar is a close relative in terms of construction and style.

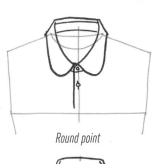

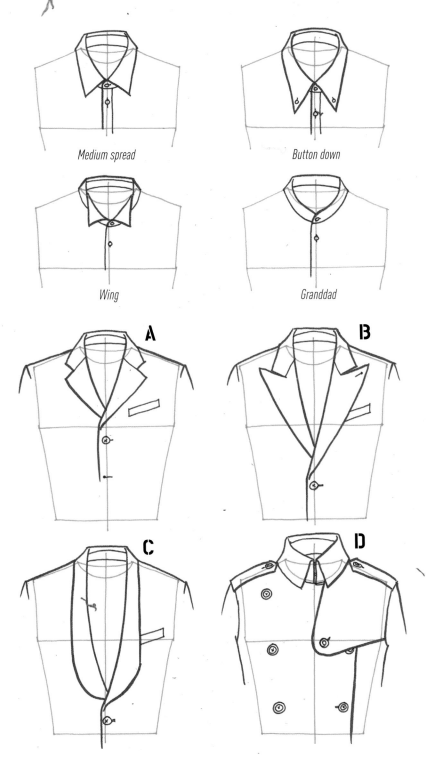

Medium spread

Button down

Round point

Wing

Granddad

Polo

A

B

C

D

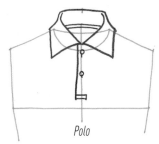

There are also endless varieties of jacket collars, lapels or revers, as well as many crossover styles. Cut almost always in at least two parts, collars and lapels can be complex and require close investigation in order that they can be constructed and drawn correctly.

A *Simple notched lapel*
B *Peaked lapel or rever*
C *Shawl collar*
D *Two-part or stand collar, with double-breasted closure and storm flap. (The latter's name refers to a style with military origins that also includes epaulettes.)*

GETTING THE STYLE AND DETAILS RIGHT – WOMENSWEAR NECKLINES, DRAPERY AND SKIRTS

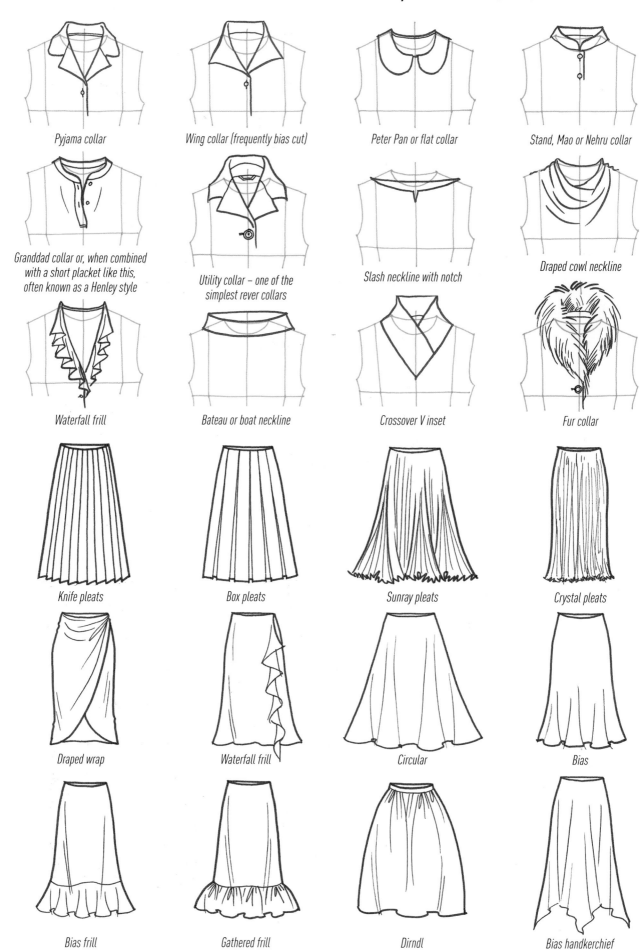

Pyjama collar

Wing collar (frequently bias cut)

Peter Pan or flat collar

Stand, Mao or Nehru collar

Granddad collar or, when combined with a short placket like this, often known as a Henley style

Utility collar – one of the simplest rever collars

Slash neckline with notch

Draped cowl neckline

Waterfall frill

Bateau or boat neckline

Crossover V inset

Fur collar

Knife pleats

Box pleats

Sunray pleats

Crystal pleats

Draped wrap

Waterfall frill

Circular

Bias

Bias frill

Gathered frill

Dirndl

Bias handkerchief

GETTING THE STYLE AND DETAILS RIGHT – POCKETS

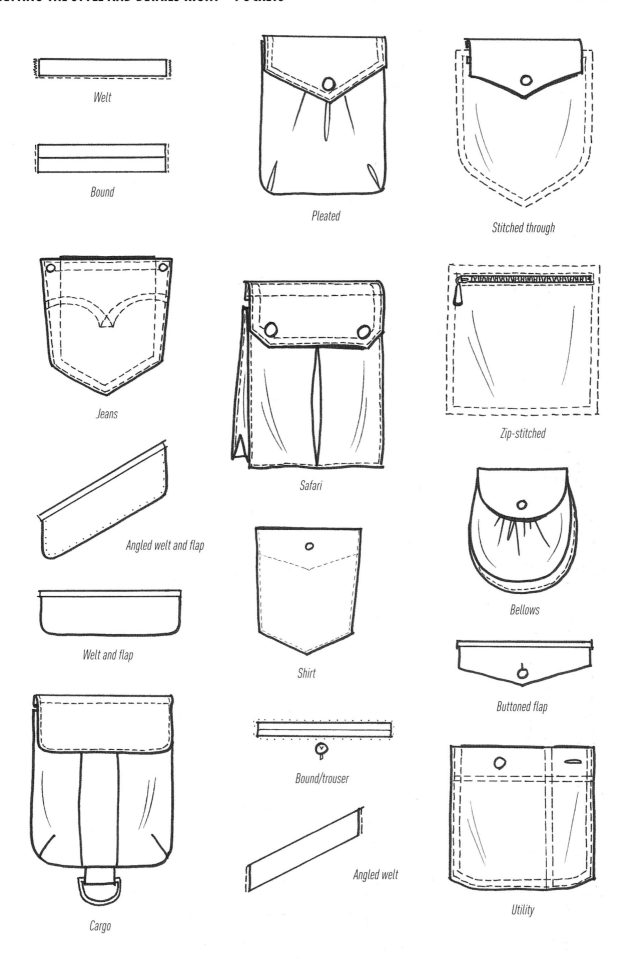

Welt

Bound

Pleated

Stitched through

Jeans

Safari

Zip-stitched

Angled welt and flap

Welt and flap

Shirt

Bellows

Buttoned flap

Cargo

Bound/trouser

Angled welt

Utility

GETTING THE STYLE AND DETAILS RIGHT – STITCHING AND DETAILS

Here we show you some examples of different stitches and finishes, but you are always going to encounter new and different types. The trick is to experiment and to develop your own shorthand versions as you come across different types.

Bound edge

Jersey twin needle

Blanket stitch

Flat lock/cover seam

Single

Twin needle

Triple top stitch

Whip stitch

Small saddle

Stabstitch

Shirred

Keyhole buttonhole

Wide elastic-cased waistband

Fastener

KNITWEAR DETAILS

Drawing knitwear has its own particular set of problems and considerations; not only are you drawing the style and detail of the garment, but also the texture, pattern and structure of the knit itself. Again, knowing a little about knitting will inform your ability to draw it. Understanding the characteristics that give the garment its identity, such as a rib, a cable or a jacquard, is key to successfully rendering the idea.

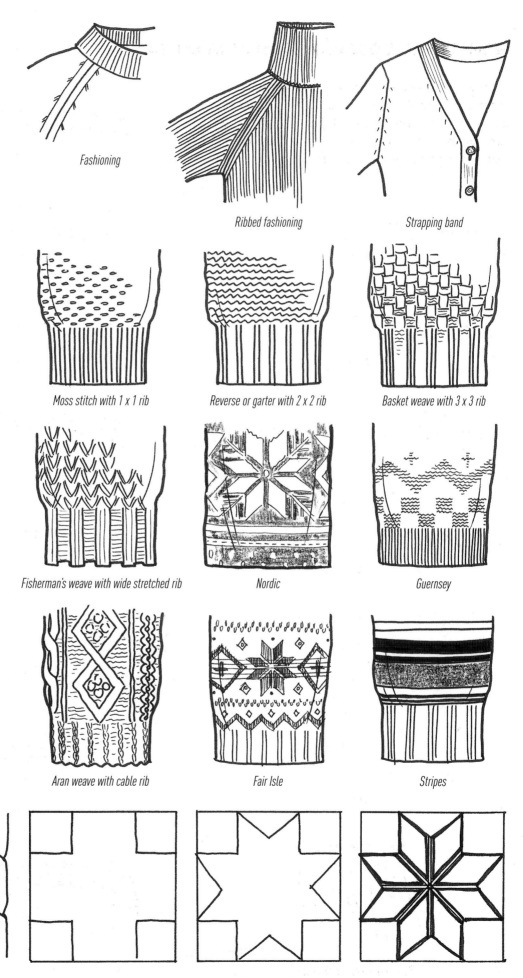

Fashioning

Ribbed fashioning

Strapping band

Moss stitch with 1 x 1 rib

Reverse or garter with 2 x 2 rib

Basket weave with 3 x 3 rib

Fisherman's weave with wide stretched rib

Nordic

Guernsey

Aran weave with cable rib

Fair Isle

Stripes

3 stages cable

3 stages snowflake

DRAWING FABRICS ON FLATS AND FLOATS

A flat drawing, particularly if it is for production purposes and to be accompanied by supporting specifications, will often for clarity consist of a simple outline, without added detail or any indication of the type of fabric used. However, if flats are intended to be more illustrative or are for designing purposes you may choose or need to illustrate fabrics. The manner in which you depict pattern on a flat needs careful evaluation and, as experience will show, it can be too much – too visually confusing and flattening – to fill in all the garment areas with colour. Practice will help you decide the right level of illustration for each job.

There are various ways of showing the fabrics:

- Include a swatch of the actual fabric or a drawn swatch.
- Draw a 'focus circle' showing an enlarged area.
- Draw just a suggestion of the fabric in a limited area that fades out to white or a background colour.

Men's raincoat
Outline: *Brush pen*
Seams and pockets: *0.5 mm fibre-tipped pen*
Top-stitching: *0.1 mm fibre-tipped pen*
Lining: *Chinagraph pencil*
Colour: *Marker pen and chinagraph pencil.*

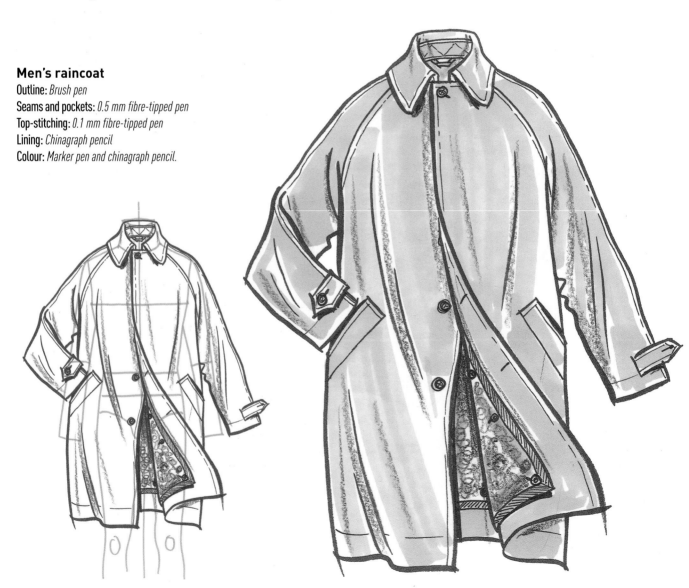

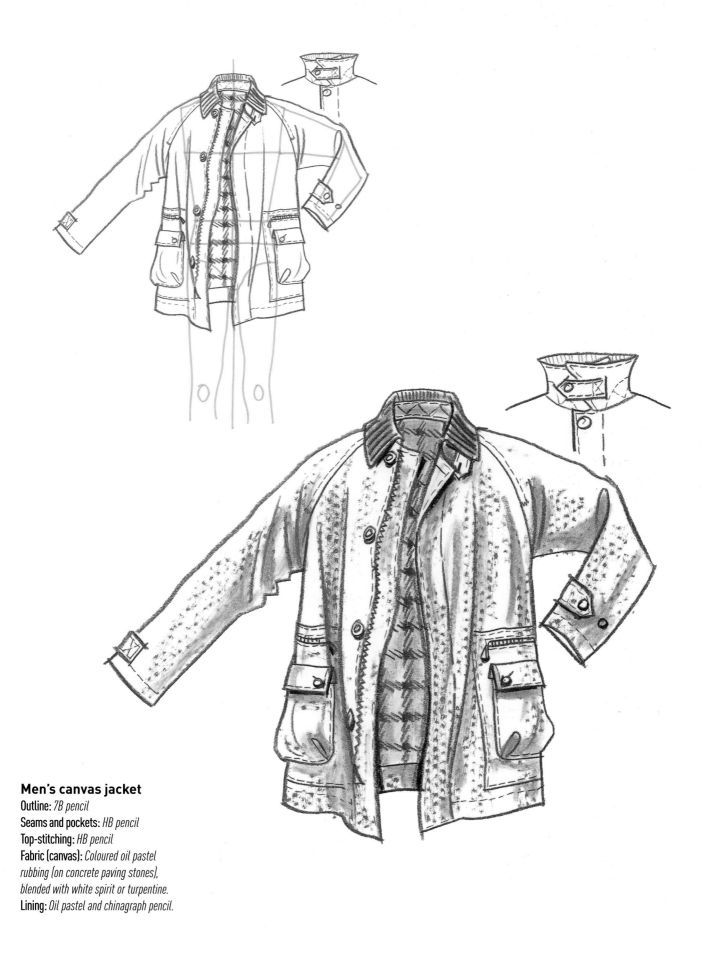

Men's canvas jacket
Outline: *7B pencil*
Seams and pockets: *HB pencil*
Top-stitching: *HB pencil*
Fabric (canvas): *Coloured oil pastel rubbing (on concrete paving stones), blended with white spirit or turpentine.*
Lining: *Oil pastel and chinagraph pencil.*

Women's textured-knit cardigan
Outline: *Brush pen*
Stitchwork: *0.3 mm fibre-tipped pen*
Stitchwork: *0.1 mm fibre-tipped pen and chinagraph pencil for texture and shading*
Colour: *Marker pen.*

Dress
Outline: *Brush pen*
Gathers: *0.3 mm fibre-tipped pen*
Texture and shading: *0.05 mm fibre-tipped pen.*

Vintage skirt
Outline: *Brush pen*
Shading: *7B pencil.*

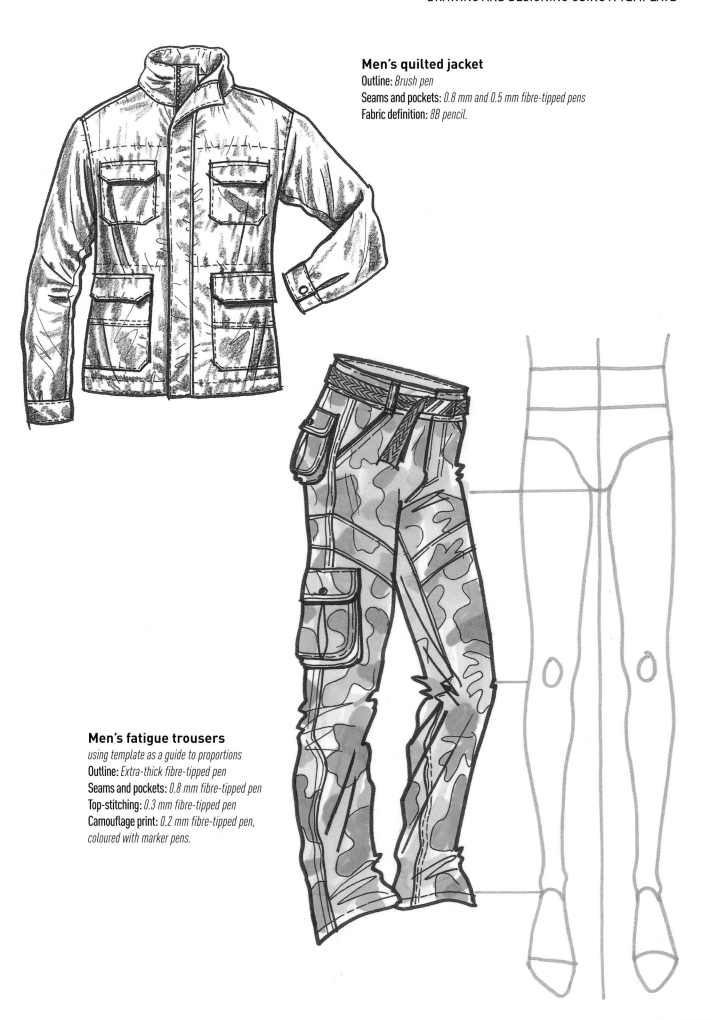

Men's quilted jacket
Outline: *Brush pen*
Seams and pockets: *0.8 mm and 0.5 mm fibre-tipped pens*
Fabric definition: *8B pencil.*

Men's fatigue trousers
using template as a guide to proportions
Outline: *Extra-thick fibre-tipped pen*
Seams and pockets: *0.8 mm fibre-tipped pen*
Top-stitching: *0.3 mm fibre-tipped pen*
Camouflage print: *0.2 mm fibre-tipped pen,
coloured with marker pens.*

CAD: COMPUTER AIDED DESIGN

In the industry today, flats are increasingly created using a computer. Many designers say it takes longer than hand-drawing, but as long as the illustrator really understands the construction of the garments the results are slicker and generally more accurate and readable. You can certainly make a beautiful job of rendering details such as top-stitching, flat-locking and cover-seaming, so the jeanswear and active sportswear sections of the industry have embraced the facility. However, few designers find designing on a computer spontaneous or flexible enough when coming up with initial concepts, and this is why hand-drawn flats are still so useful.

Illustrator Martina Farrow has had a successful career as a freehand fashion illustrator and has gradually honed her computer illustration skills, from the earlier experiments with cruder programmes to the most sophisticated work using the latest developments. Although most of Martina's work is purely illustrative, her advice on learning to draw and illustrate using computers is equally applicable when drawing flats. Here she talks us through her approach:

To illustrate on an Apple Mac using Adobe Illustrator CS range or a similar programme, it's a good idea to first play with each command in the various toolboxes and settings (as you would when trying out any other materials), to get a feel for their scope, and how you may like to use them.

A logical starting point is establishing the size of the illustration. Open a new document and select its size (e.g. A4) and orientation (landscape or portrait), or select 'Custom' and enter your own artboard's dimensions in the boxes. For commercial work, it is worth bearing in mind the final file size; a bigger artboard just means a bigger file size, which can be more unwieldy to store and email. This does not apply so much for one-off illustrations.

Next, decide if you want to use one of your own digital photographic files as reference and, if so, import that to the new document, and resize it accordingly.

I generally then lock the image in place, and begin drawing over it freehand using the pencil tool or use the pen tool to accurately trace the outline. Alternatively you can just begin drawing in the programme as you would if drawing freehand on paper. A Wacom tablet and stylus are often easier to use for drawing than a mouse, so it may be worth considering purchasing these if you intend to do a lot of CAD.

Once the line drawing is complete, delete the reference picture if you have one and have a look at the lines created. These can now be adjusted and edited at their anchor points to give the desired curves and so forth, using the Direct Selection Tool, or similar.

If the finished piece is to be a line-only artwork, there are many different options for line thickness and texture. Experiment using the Stroke menu and Brush libraries. A huge range of gorgeous line thicknesses and effects can be found, including chalk, soft pencil, pastel, ink, watercolour and spatter.

Colour Swatch libraries provide almost every colour range in existence! Stroke and Fill menus generate whatever colour/line combinations you like. Fill outlines with plain colour only, generate your own patterns or delve into the Pattern libraries in the toolbox.

If a specified Pantone colour reference is required, select from the appropriate Swatch library. You can also save your own selections to a personal colour library.

Other useful menus to try are Transparency and Gradient. The Transparency option includes several settings that vary how colour can be applied. For example, Multiply can be used to overlay colours in the same way that they would appear if they were overlapping layers of coloured film.

The Gradient menu is a great device for creating a soft melding of two or more colours. All these effects can be deployed in CMYK or RGB colour or Grayscale.

The decision to add type of any font, in any colour, outline or pattern is easy; simply use the Type tool. There are also many kinds of grids and line shapes contained in the AI toolbox.

Here are some examples of flats drawn using a
computer, from a teaching aid by Lynnette Cook.

FEMALE TEMPLATE

BASIC LONG-SLEEVED TOP

BACK

FRONT

BASIC TROUSERS

FEMALE BOTTOM HALF

Waist

Hip

Crotch

Knee

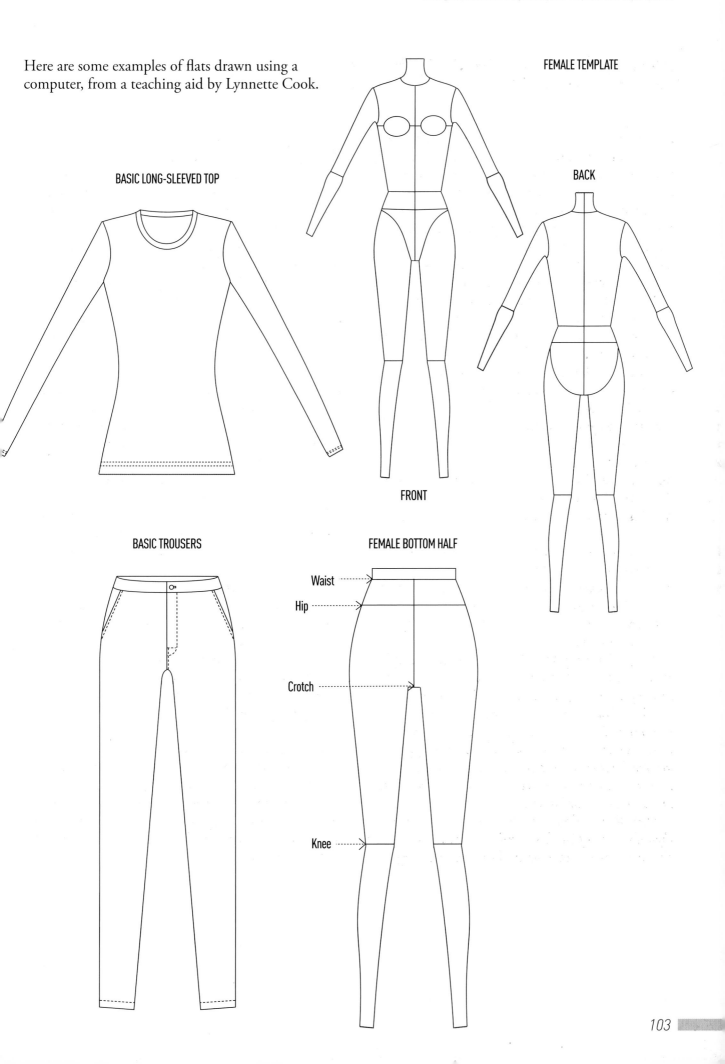

TECHNICAL OR SPECIFICATION FLATS USING CAD

These drawings were created in order to communicate the design to a manufacturer. The designs have to stand up on their own, with little more than measurements to further explain them.

It is evident that the designer had to thoroughly understand and anticipate the necessary construction of the design in order to communicate the intentions clearly and accurately.

Mariella Ertl
for ONLY Autumn/Winter 2012/13
Using ILLUSTRATOR.

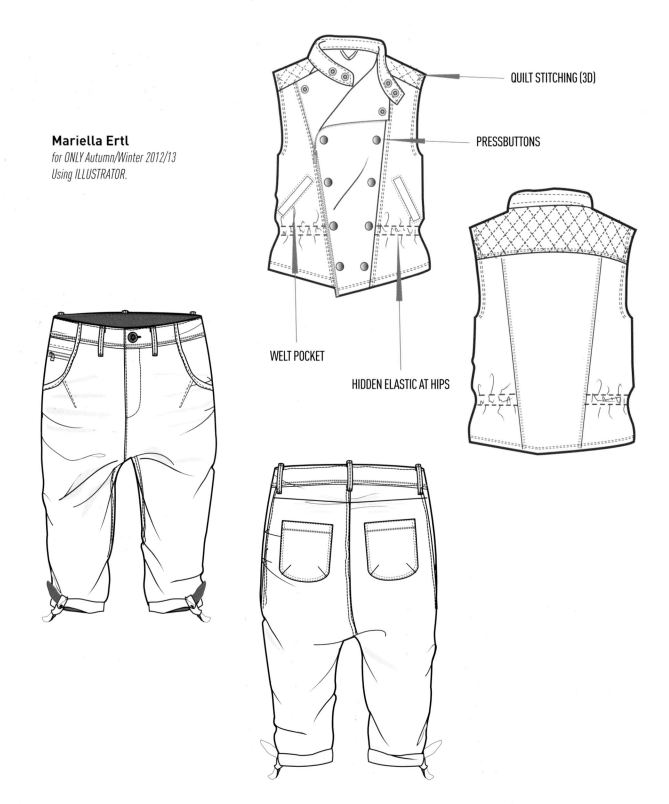

QUILT STITCHING (3D)

PRESSBUTTONS

WELT POCKET

HIDDEN ELASTIC AT HIPS

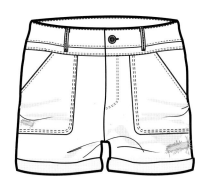

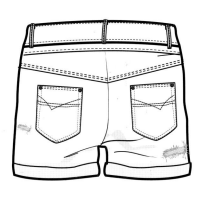

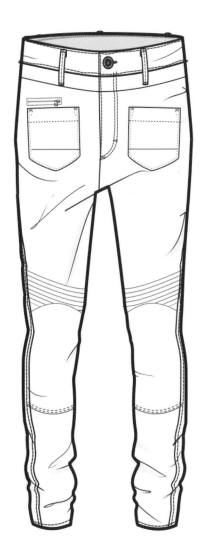

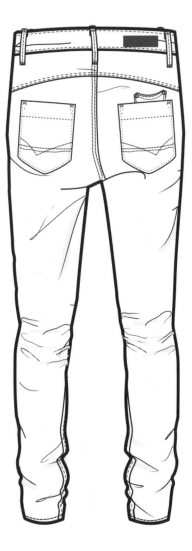

Mariella Ertl
for ONLY Autumn/Winter 2012/13
Using ILLUSTRATOR.

COMBINING FIGURES AND FLATS

Using the template from page 35 (J), you can create an outfit by drawing a combination of garments on a figure, perhaps adding colour and rendering the fabric to make them visually appealing. For clarity, these can be accompanied by an individual flat of each garment.

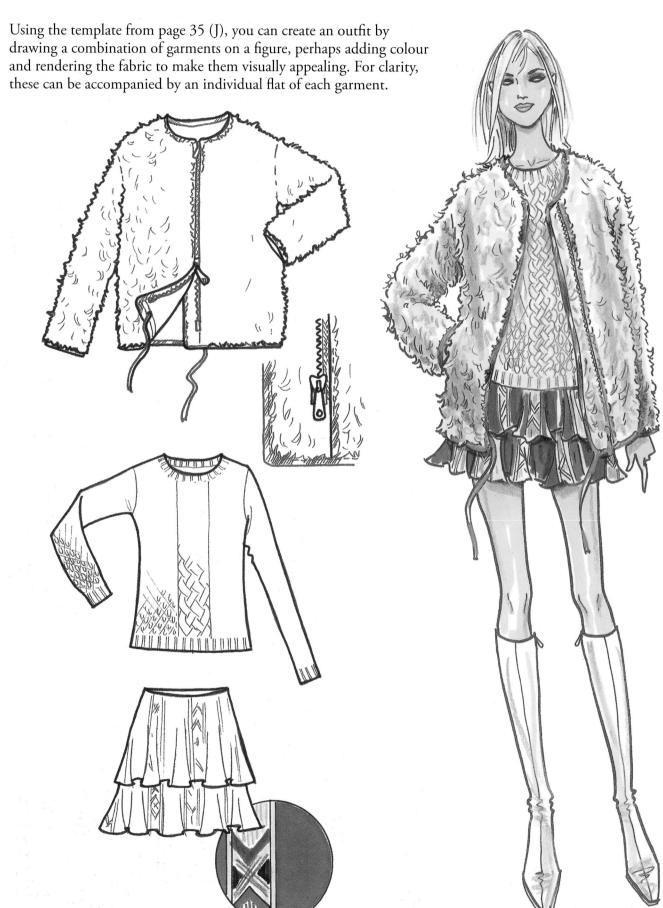

ILLUSTRATIVE FLOATS

This accessorized, finished outfit is based on the template on page 88 and is drawn as a float using soft pencil (8 or 9B). This is the style of illustration that you may expect to see in magazine features about 'must-have looks'.

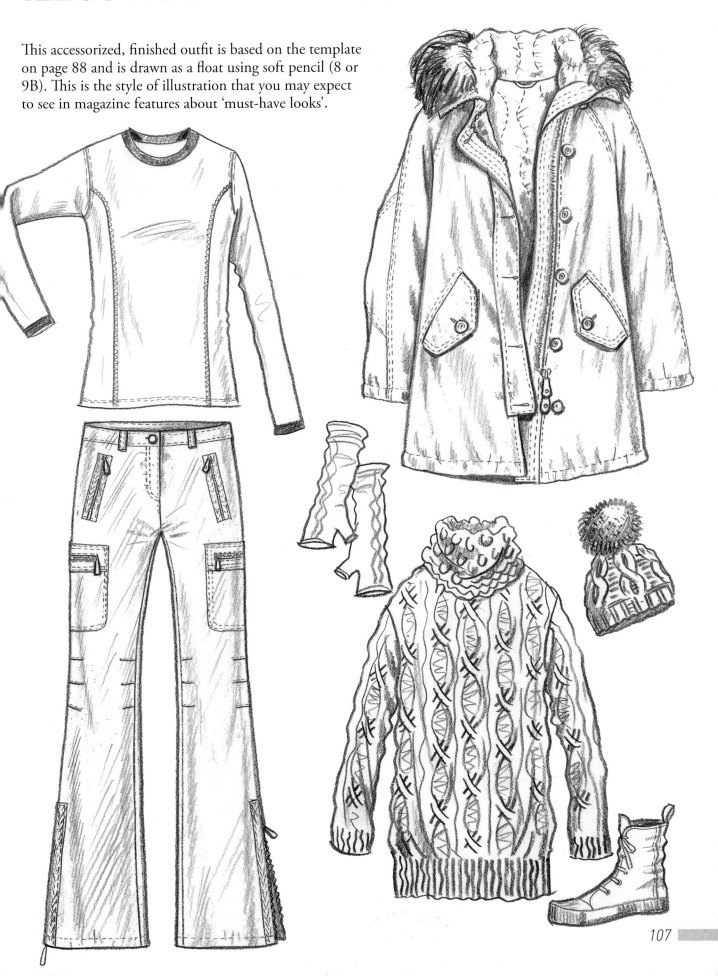

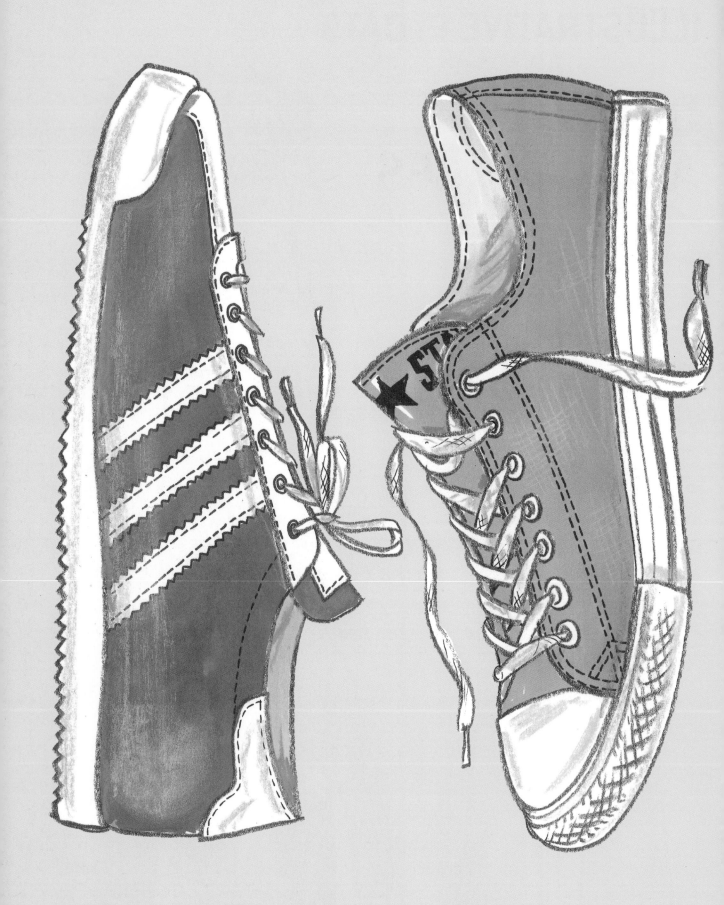

DRAWING ACCESSORIES

Just as fashion expands to encompass ever-developing markets, so the demand for accessories expands too. Every fashion niche now has an accompanying range of accessories and so the scope for designing, drawing and illustrating them has grown.

Drawing accessories can incorporate many of the skills we've learnt already. Since by their very nature accessories are often small and very detailed, a fairly graphic drawing style – midway between that used for drawing designs on a figure and that used for creating flats – is often the most successful means of communication. With a little practice and experimentation you'll soon discover what works best for you and for particular project briefs.

One advantage of drawing garments is that, consciously or not, we acquire visual awareness and knowledge of clothing through wearing and handling it. We understand how the flat shapes that make up the garment have created its form. But with shoes, which hold their shape when we take them off, we often do not have that extra knowledge of structure and component shapes. A little extra work is usually necessary to carefully observe and visually analyse accessories like shoes.

You may also encounter a slightly different range of materials when drawing accessories. It is important to familiarize yourself with these materials – with leather and suede in various grades and qualities, and with metal clasps and fastenings – not to mention all the other materials that may be used to make or decorate a shoe.

Then there are the practical aspects of the design to consider: for example, a wallet or bag may have a particular mechanism for closing or a way of folding that must be explained in your drawing, so you might decide to draw it open or part-open. If you are drawing a design of your own – of something that has not yet been realized – then you can use the drawing process as a way of problem-solving, drawing and redrawing to refine certain aspects and to come up with the best design.

CREATING TEMPLATES

As with figure drawing, where possible it can be a great help to create a template. Doing this will bring to the fore the first of several questions you need to answer, namely whether you wish to show the item on or off the body. This may be especially relevant when illustrating footwear, for instance, as it may be quite tricky to convey the subtleties of a design if it is not being displayed correctly. This is particularly true of strappy shoes, which may be limp and have very little integral form when viewed off the foot, and so are best shown being worn.

With this in mind, it is a good idea to develop a small range – a library if you like – of useful templates like those shown opposite. These provide a quick and accurate means of depicting a foot in the correct position for each of the different kinds of shoes you wish to draw or design. They are likely to include foot positions for flat and heeled shoes, and perhaps one of each with a leg present for drawing boots. Similarly, it is a good idea to have a bank of templates for well-proportioned heads seen from various angles, torsos, and many hand poses.

In order to create these, simplify the body parts into geometric shapes such as boxes, spheres and triangles and sketch them lightly in pencil. You can then begin to plot out the primary proportions and details. Once you are happy with these, you can complete the details, and finally ink over the finished shape and delete the pencil marks.

When drawing some accessories you may find that conveying scale can be a problem; just how big is that bag or purse? You might notice in magazines that accessories are sometimes photographed with a standard-size object – a lipstick or perfume bottle with a bag, a shoe with a holdall and so on – as this helps to portray the scale of the items. With a little imagination, this is a trick you can employ equally well in your drawings. Dressing a figure with the accessory is also a good way of clarifying its size. A scarf, for instance, can be anything from a small square handkerchief to an enveloping shawl. However, by showing it being worn, the scale and intention becomes obvious.

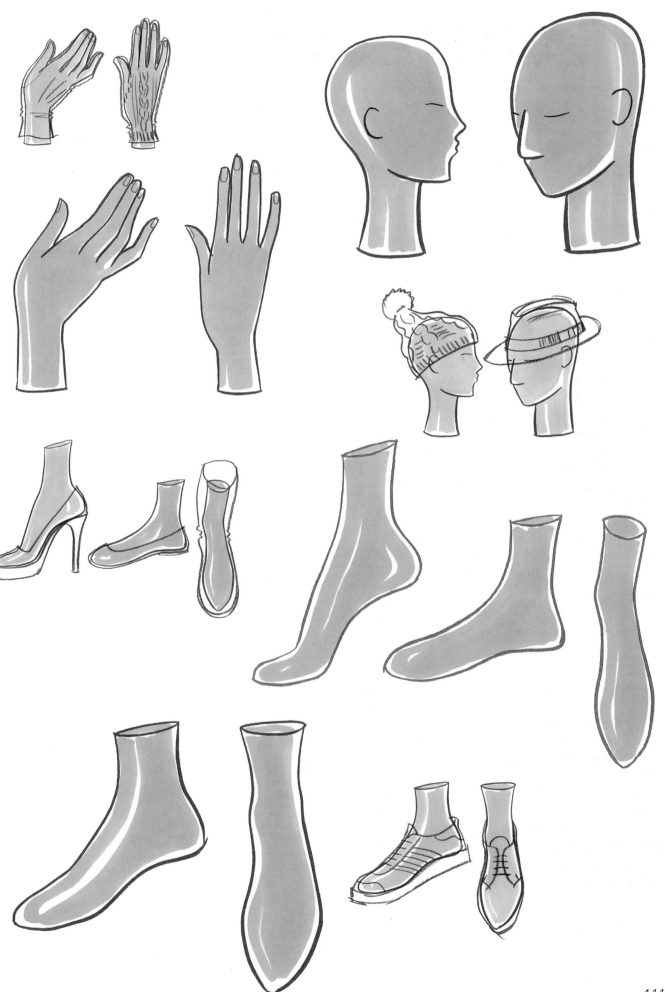

HOW TO DRAW SHOES: WOMEN

These examples show how shoes can be drawn using a range of mediums, including marker pen, pencil, oil pastels, soft crayons and many others. Simple techniques such as rubbings have also been employed. Plan some experimentation time into your schedule so that you can try new techniques and different mediums.

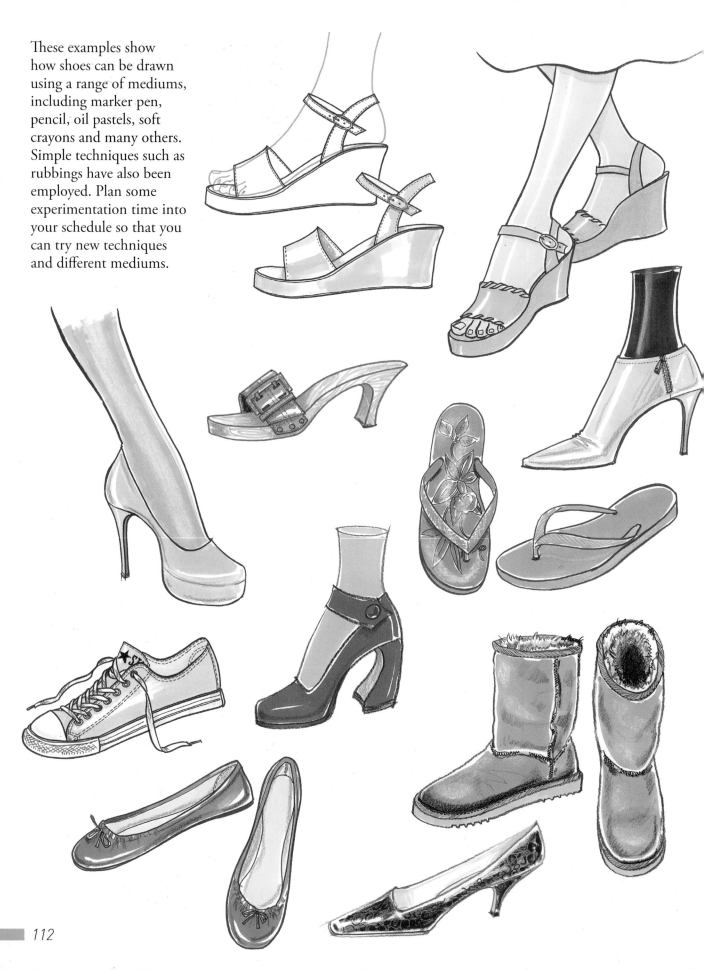

HOW TO DRAW SHOES: MEN

Techniques for drawing men's shoes are the same as for women's. If you are drawing men's and women's shoes on the same page, remember to draw the men's slightly larger, as they probably would appear in reality, so that they read correctly.

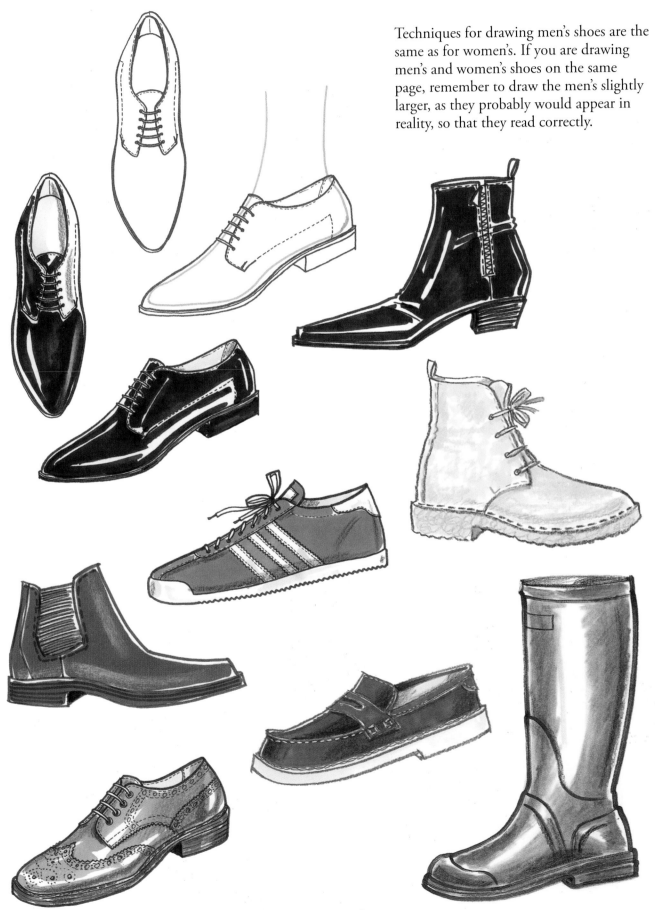

HOW TO DRAW BAGS: WOMEN

When drawing something like a bag, a template really is not possible unless you are drawing versions of the same basic form. So, it's best to begin by sketching a simplification of the shape in light pencil. As when drawing garments, first plot out the primary proportions and details, then refine and add finer details, and only once you are completely satisfied should you ink in the illustration or use a more permanent medium.

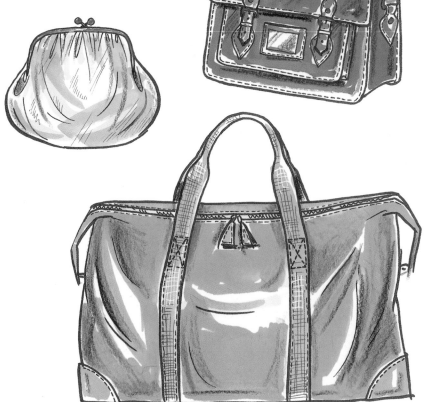

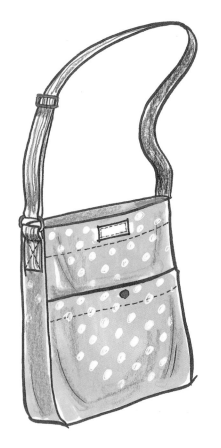

HOW TO DRAW BAGS: MEN

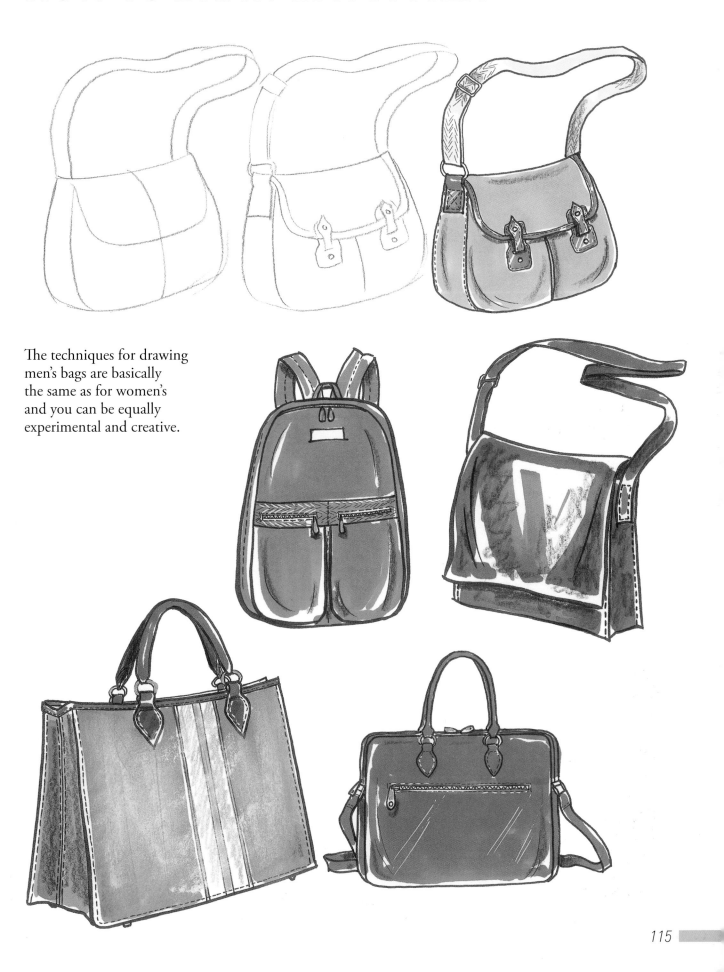

The techniques for drawing men's bags are basically the same as for women's and you can be equally experimental and creative.

GROUPING ACCESSORIES: WOMEN

These layouts or round-ups of accessories are similar to pages you may see in magazines, for instance features on 'How to do the latest look', 'Key must-have pieces' or 'Seasonal gifts'. A range of rendering techniques are employed and the items are arranged in a clever way so that their scales, proportions and intended usage are apparent, and they are shown to their best effect.

GROUPING ACCESSORIES: MEN

Men probably have the same amount of accessories as women, although some will be different, of course – but all will offer fun drawing challenges and opportunities for experimentation.

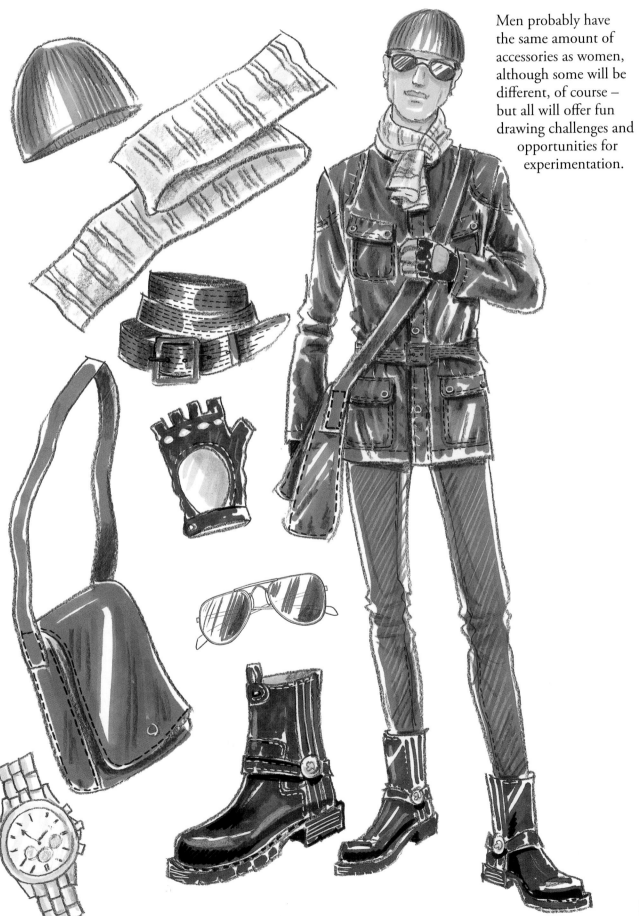

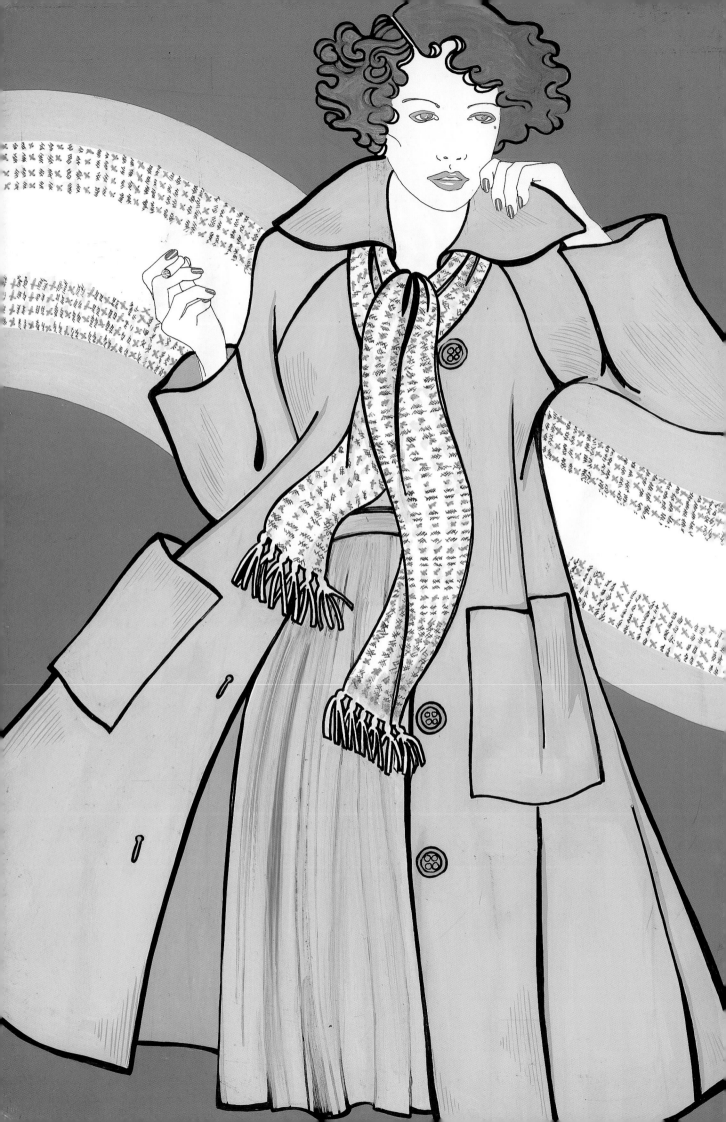

CHAPTER 8

FASHION ILLUSTRATION GALLERY

We begin this chapter with a small project that shows how a single garment can be drawn using a number of different styles and techniques. The chapter then showcases a wide range of fashion drawings for prestigious clients by some of the most illustrious international designers, as well as rising talents. Other images have rarely been seen by the public, and reveal the working practices of the artists and designers, including how items are drawn and redrawn to refine proportions and details, the hastily scribbled 'notes to self' that many designers use during the development process, and the more polished, precise and informative drawings used to communicate the design to manufacturers. The breadth of styles presented is stunning.

In the same way that fashion is cyclical – trends ebb and flow, are revived and refreshed, deconstructed and reassembled – the style of fashion drawings also changes, and this is evident when a vintage artwork is juxtaposed with a more contemporary illustration. While some appear timeless, others provide a stark contrast and offer a glimpse of alternative, individual and inspiring ways of expressing design that could be interpreted and adapted to suit today's technology-assisted methods.

Some drawings fulfil their roles with quiet efficiency, others sing with the energy of their execution, their captured vitality. When viewing some illustrations it is as if we are entering another world and find ourselves mid-story in a fantasy where fashion, clothes and accessories take on starring roles. In others, realism and accurate representation take precedence, and a tighter, less flamboyant but nevertheless graphic style dominates. All are equally valid if the artworks fulfil their briefs.

During the course of this book we have learned some of the rules and requirements of a good drawing – with perhaps the most important being that it is 'fit for purpose'. This end result is achieved through a process of recording and generating ideas in a sketchbook, drawing and refining designs, and constantly accessing and judging a drawing so that the garment or outfit it represents is attractive and technically accurate and conveys the idea behind the project in an appealing manner. However, as we shall see here, some rules can be pushed to their limits (although the design must remain fit for purpose), and it is having the skills to know how and when to do this that is the mark of a great designer or illustrator.

SO, HOW ARE YOU GOING TO DRAW THAT PARKA?

Having grasped the essential skills outlined in this book, and grown in confidence and proficiency, you can now start to push the boundaries and develop your own style. This is likely to include experimenting with different mediums and ways of working, and there are also some tricks of the trade that you can use to help you build a portfolio of work that reflects your own interests, particular skills and abilities, and what is generally known as your own 'handwriting'. Here you can see how the same type of garment can be approached using very different techniques and drawing styles.

Martina Farrow
Client: *Cambridge University Press*
Agent: *New Division*
Drawn freehand using Adobe Illustrator, this charming artwork for an editorial story on camping features a loosely drawn parka-type garment along with other related paraphernalia.

Alice Fletcher-Quinnell
This lively drawing by Alice Fletcher-Quinnell has a youthful, casual and spontaneous atmosphere. Although the garments are perfectly recognizable, the illustration says less about the finer details of the clothing and far more about a modern fashion attitude. This image was created using monoprinting and Adobe Photoshop.

Judith Cheek

This illustration was drawn in a loose, confident style. The outlines of the figure were first sketched in with a soft 6B pencil, then watercolour wash was used to fill in the garments. White highlights were reserved with a wax resist pencil and masking fluid. The simplest watercolour background of a blue sky grounds the figure and provides atmosphere and setting. Detail is accurately portrayed, but not over-complicated.

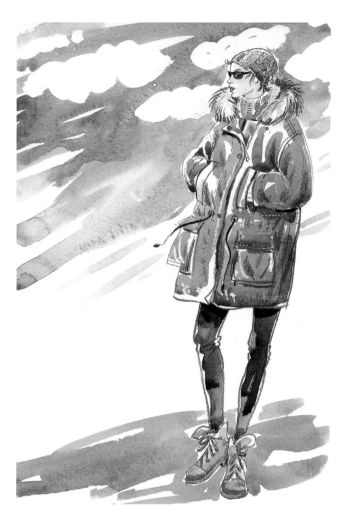

Judith Cheek

This free, quick sketch energetically captures the essence of the stylish juxtaposition of a utilitarian parka with a glamorous party dress.

Judith Cheek

This graphic image was created using collage. First, the simplified figure and garments were cut out from coloured paper and then fixed to a background with Spray Mount adhesive. The details of the garment and facial features were then added in pastel, with drawing kept to a minimum so that the lines remain bold and simple.

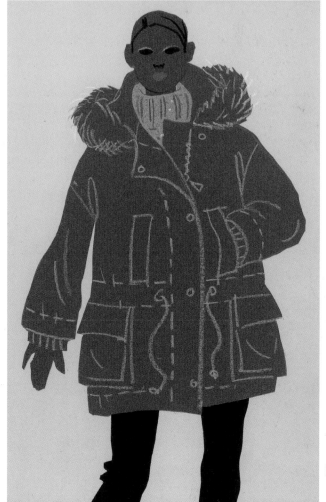

GALLERY

Howard Tangye
'Maya' Galliano girl (Autumn/Winter 2007), drawn in situ in the John Galliano studio in March 2007. Mixed media, including oils, pastel and graphite on paper.

Hilary Kidd
A simple yet effective image drawn with a brush pen.

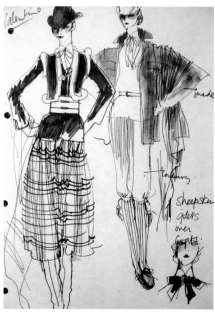

Elizabeth Suter
Drawn at the 'Collections', 1978. Fibre-tipped pen, pencil and marker pens.

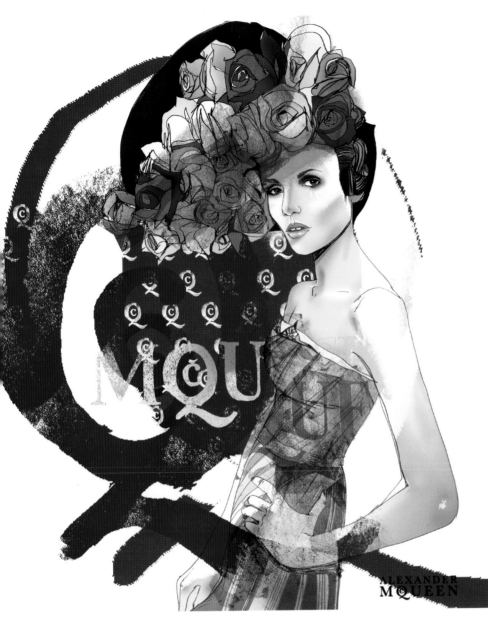

Patrick Morgan

Illustration for Alexander McQueen, created using pen and ink, pencils, crayons, rollers and stencils on 310 Somerset paper. Scanned and colour-managed in Photoshop.

Patrick Morgan

Drawn using pen and ink and pencil on 310 Somerset paper.

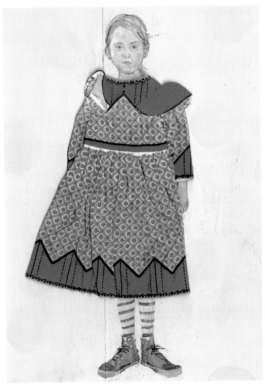

Claire Fletcher

Illustration using acrylic paint on wood and a collaged doll's dress.

Lesley Hurst
Client: Textile View Magazine
*Illustrations created using
Photoshop, collage and
watercolour.*

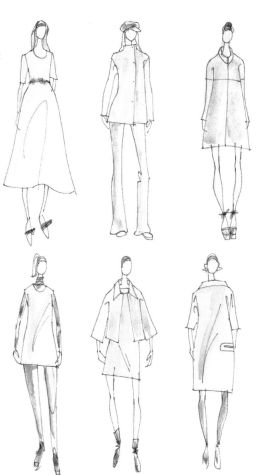

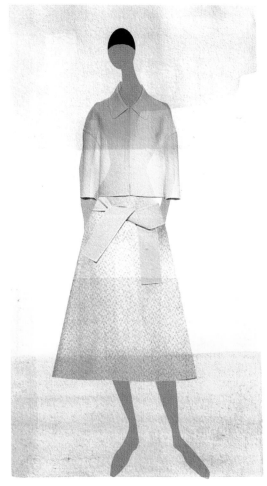

Lesley Hurst
Client: Textile View *Magazine
Illustrations created using
Photoshop, collage and
watercolour.*

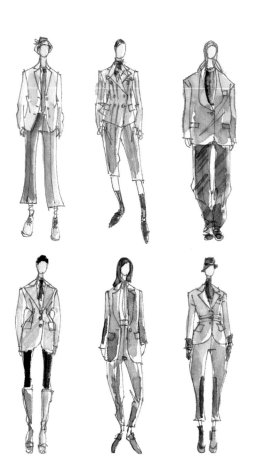

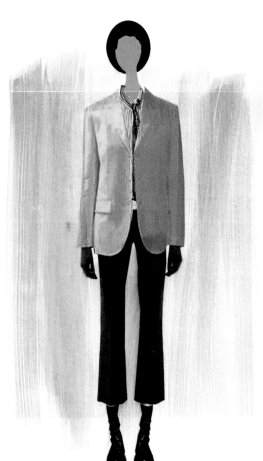

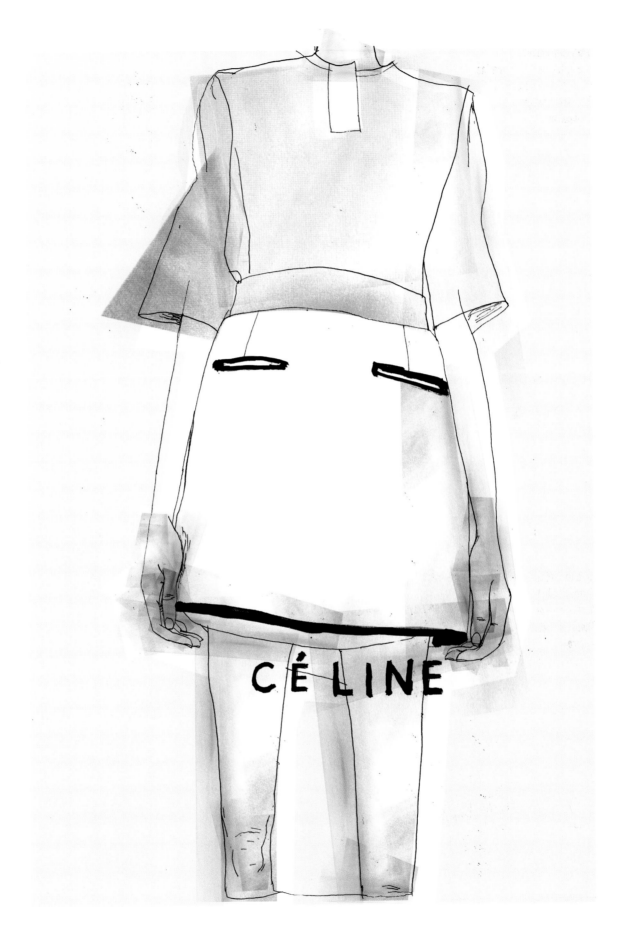

Patrick Morgan
Illustration using pen and ink and pencil along with
rollers and stencils on 310 Somerset paper. Scanned
and colour-managed in Adobe Photoshop.

Judith Cheek
Silk screen print.

Cath Knox
*A striking illustration drawn
using pen and black ink.*

Cath Knox
*Fibre-tipped pen was used
to create this drawing.*

Stina Persson
Client: *Sigerson Morrison, 'Belle'*
Watercolours were used to paint these shoes.

Hilary Kidd

*Figures rendered using brush pen,
marker pens and crayon.*

Ian Batten

*Design drawings created using
fibre-tipped pen.*

Hormazd Narielwalla
Exhibited at the 'Markt' exhibition at SCOPE, New York, this was an editorial for Coilhouse magazine, and depicts the late performance artist Klaus Nomi. It is a digital collage of vector illustrations and photographs of tailoring patterns.

Lynda Kelly
St Martin's School of Art, 1938–40. A vintage illustration created using mixed media, including watercolours and crayon.

Rosalyn Kennedy
Illustration using brush pen, charcoal and soft pastels on coloured paper.

Lynda Kelly
St Martin's School of Art, 1938–40.
A vintage illustration using mixed
media, including pen and ink and
watercolour wash.

Martina Farrow
Agent: New Division
'Shop', Promotional work 2010/2011
Artwork created using Adobe Illustrator CS3.

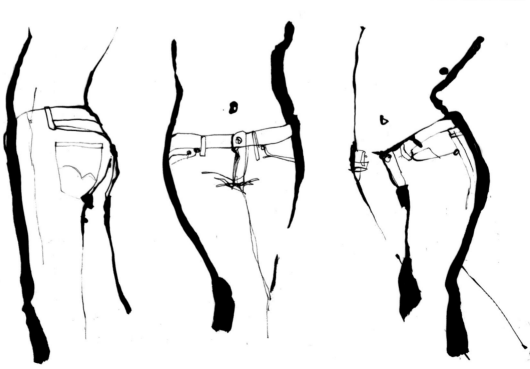

Stina Persson
Client: *Levi's*
Ink drawings used in-store
and on hangtags for the
2010 'Levi's Curve ID' line.

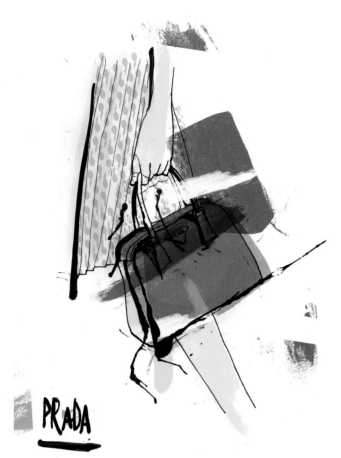

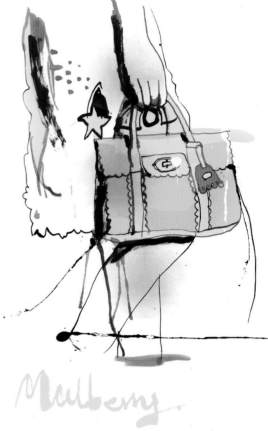

Patrick Morgan

Drawn using pen and ink and pencil on 310 Somerset paper. Brushes, crayons, pens, pencils, rollers and stencils were used for mark-making on block areas. Scanned and colour-managed in Adobe Photoshop.

Cath Knox

Ink and gouache were used to create this image.

Howard Tangye

'Sue B': a portrait of a friend made using mixed media, including ink and collage of torn paper.

Lynda Kelly

St Martin's School of Art, classwork, 1939. A vintage illustration created with mixed media.

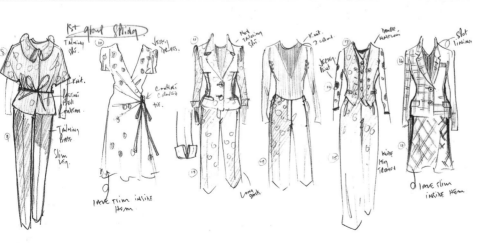

Bruce Robbins

Design drawings in soft pencil.

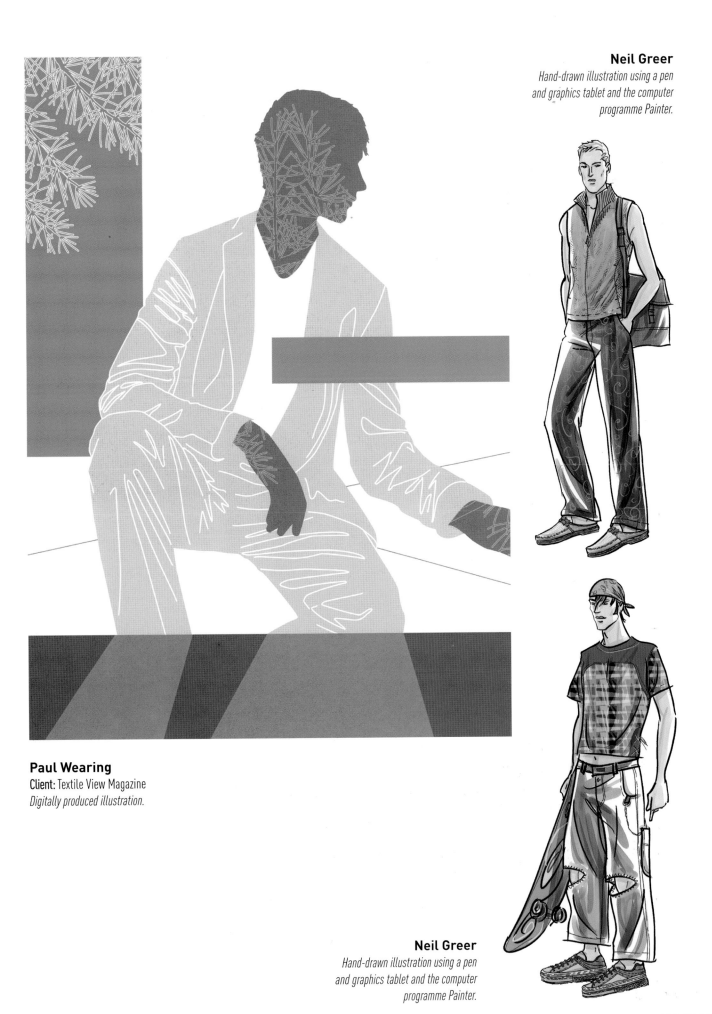

Neil Greer
Hand-drawn illustration using a pen and graphics tablet and the computer programme Painter.

Paul Wearing
Client: Textile View Magazine
Digitally produced illustration.

Neil Greer
Hand-drawn illustration using a pen and graphics tablet and the computer programme Painter.

Cath Knox
*Illustration drawn with
fibre-tipped pen.*

Elizabeth Suter
*Drawn at the 'Collections' in
1978, using fibre-tipped pens,
pencil and marker pens.*

Judith Cheek
Oil pastel illustrations.

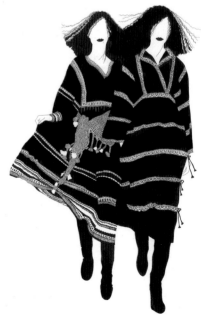

Anthea Simms
*Monochrome image using
Indian ink.*

Claire Fletcher
*Illustration using acrylic
paint on paper.*

Cath Knox
Client: *Cotton Board,
Summer 1975.
Illustration using marker
pen and pencil.*

135

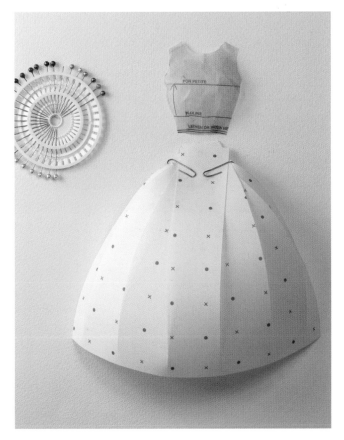

Lesley Hurst
Client: Textile View Magazine
Created with paper collage.

Lesley Hurst
Client: Textile View Magazine
Created with paper collage.

Patrick Morgan
FACING PAGE: *Illustration drawn with pen and ink and pencil on
310 Somerset paper. Brushes, crayons, pens, pencils, rollers and
stencils were used for mark-making on block areas. Scanned and
colour-managed in Adobe Photoshop.*

Judith Cheek
Silk screen print.

accessoire

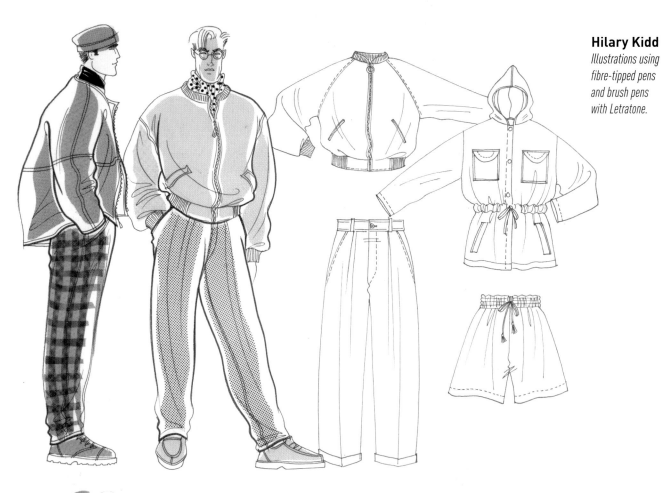

Hilary Kidd
Illustrations using fibre-tipped pens and brush pens with Letratone.

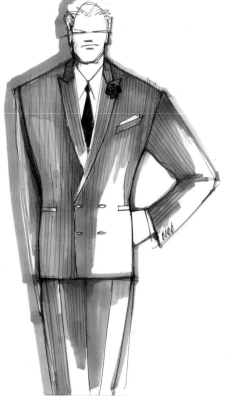

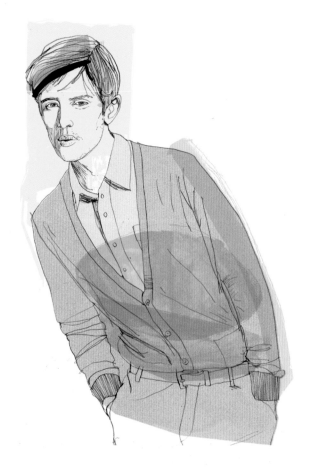

Charlie Allen
'Summer Wedding', drawn with ballpoint pen and marker pens.

Patrick Morgan
Illustration drawn with pencil on 310 Somerset paper. Brushes, crayons, pens, pencils, rollers and stencils were used for mark-making on block areas. Scanned and colour-managed in Adobe Photoshop.

LOOK 4
SPENCER SPORT SUIT
BLACK & WHITE SILK LINEN BIRDSEYE
PEAK LABEL
SINGLE BREASTED DEUX PIECE
SHIRT
BLACK & WHITE COTTON GRAPHIC PAISLEY
PRINT
HIGH COLLAR STAND
ACCESSORIES
DEEP NAVY SILK POLKA DOT TIE
BLACK SILK BOXED POLKA DOT
POCKET SQUARE
18 KT CYLINDER STRIPE YELLOW GOLD
CUFF LINKS
SHOE
TWO-TONE CROCODILE BOAT SHOE
WITH TASSLE

Patrick Morgan
*Image drawn with pen and ink and pencil on 310 Somerset paper. Brushes, crayons,
pens, pencils, rollers and stencils were used for mark-making on block areas. Scanned
and colour-managed in Adobe Photoshop.*

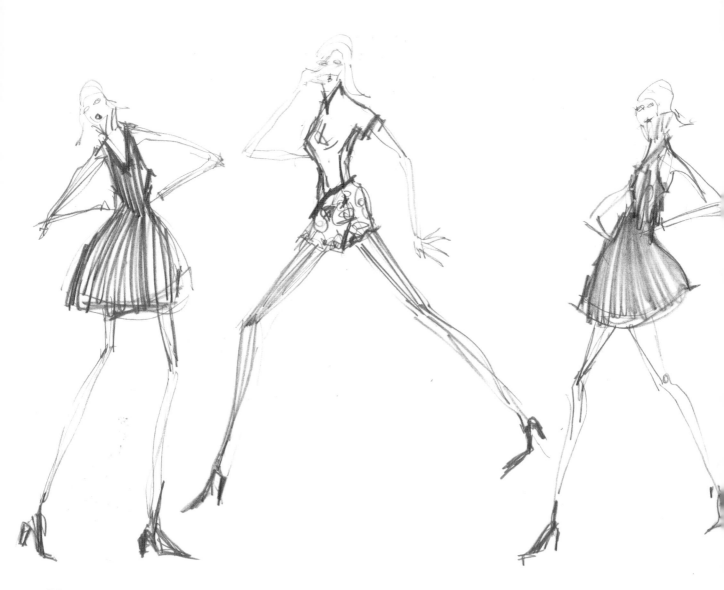

Pik Yee Berwick
Soft pencil sketch.

Hormazd Narielwalla
Digital collage.

Yvonne Deacon

Here, outlines were sketched in pencil, then the artwork was scanned and outlines were filled in using Adobe Photoshop.

Patrick Morgan

Drawn with black ink and pencil on 310 Somerset paper.

Yvonne Deacon

BELOW: *Artwork using pencil, watercolours and an ink splodge collage on paper. Scanned and finished using Adobe Photoshop.*

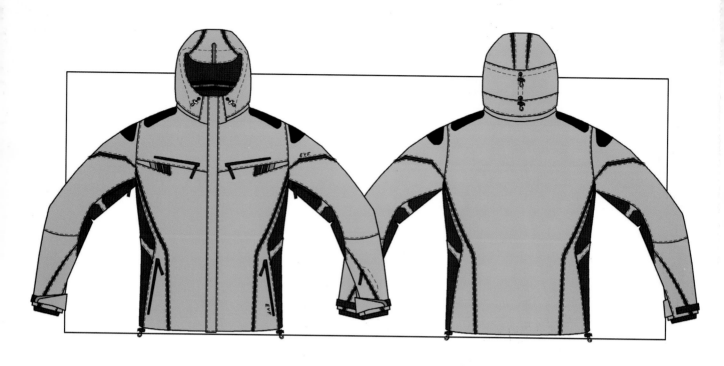

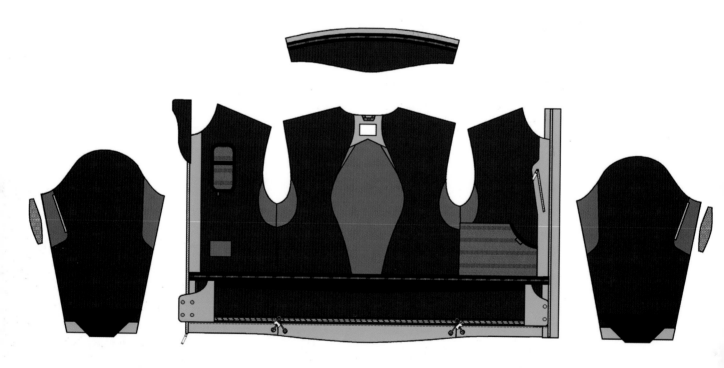

Clare Dudley Hart
Client: *EVF Ltd – Skiwear technical drawings*
Drawings produced digitally.

Paul Wearing
FACING PAGE
Client: Textile View Magazine
Digital illustration.

Martina Farrow
Agent: *New Division*
'Floral' - Promotional work 2010/2011
Created using Adobe Illustrator CS3.

Hilary Kidd
Illustration using brush pen, marker pens and crayon.

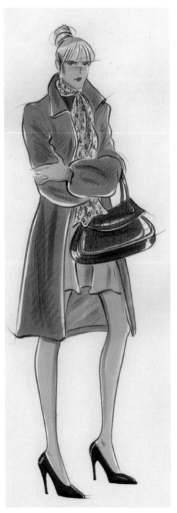

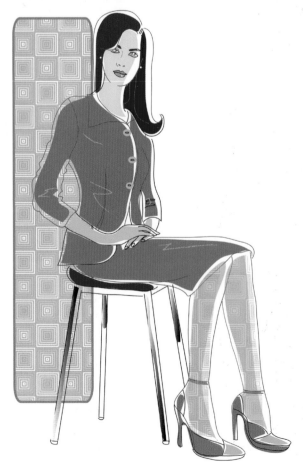

Lynnette Cook
'Lady Lou'
Created using Adobe Illustrator CS3.

Rosalyn Kennedy
Illustration using brush pen, pencil,
watercolour and pastel.

Howard Tangye
'Emilie', a drawing for Elisa Palomino 2009–10
Mixed media on paper.

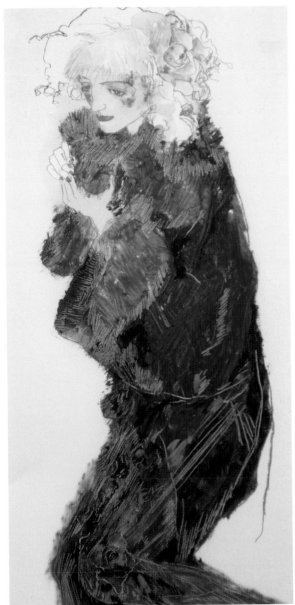

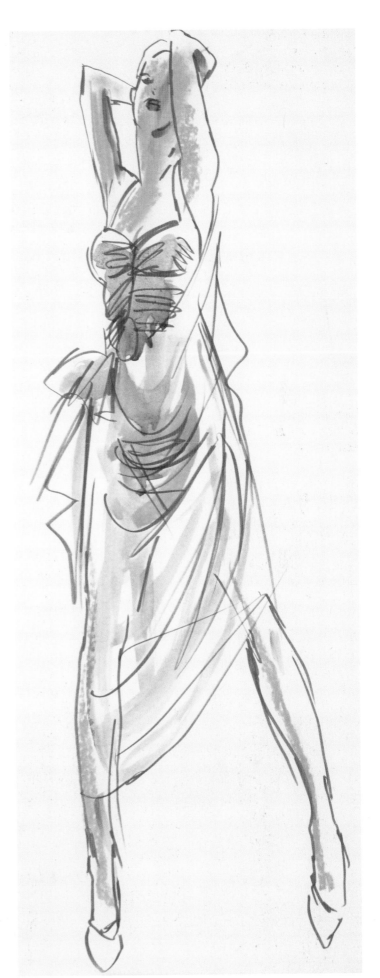

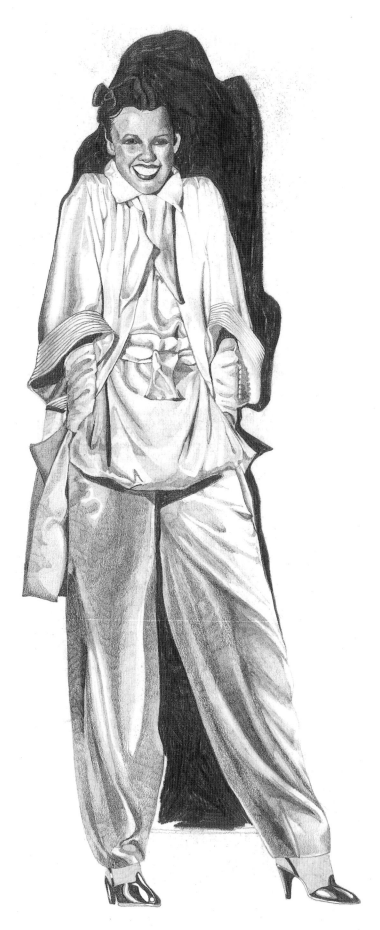

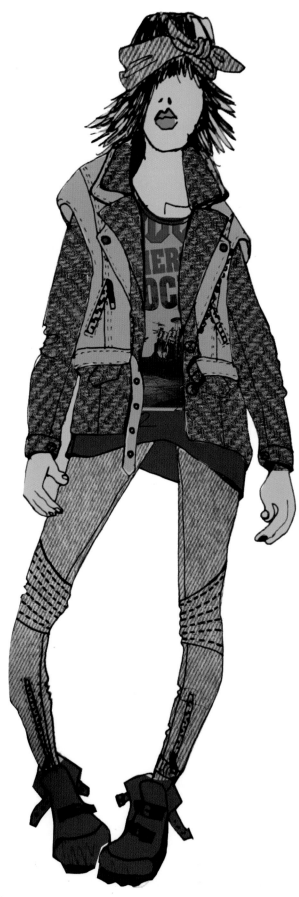

Anthea Simms
Pencil drawing.

Katharina Gulde
Client: *ONLY Bestseller*
Hand-drawn and digitally manipulated.

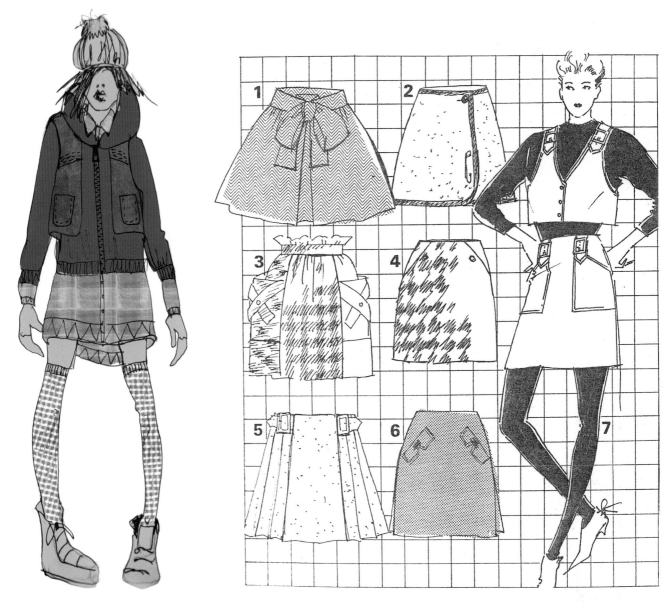

Katharina Gulde
Client: *ONLY Bestseller*
Hand and digital drawing.

Rosalyn Kennedy
Client: *Nigel French Enterprises*
Fibre-tipped pen with Letratone.

Hilary Kidd
Hand-drawn using brush pen, marker pen and chinagraph pencil.

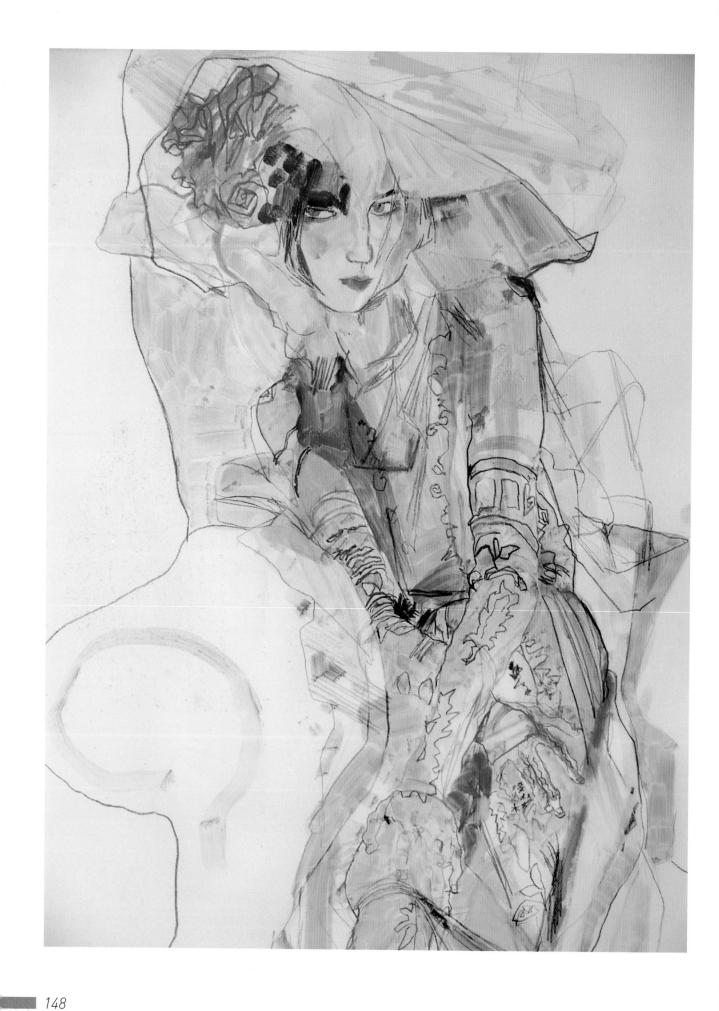

Howard Tangye
FACING PAGE
'Elodie' Galliano girl (Autumn/Winter 2007), drawn in situ in the Paris studio of John Galliano. Created using mixed media on paper.

Paul Wearing
Client: *Neiman Marcus – The Book*
Digitally produced illustration.

Sophia Kokosalaki
Client: *Christina Gourdain
wedding commission
Hand-drawn and scanned
to computer.*

Henrietta Goodden
Client: *Publicity for Italian Lace,
Autumn/Winter 2006
Roughs/design drawings in pencil.
Finished drawing in brush pen, black
crayon and Letratone.*

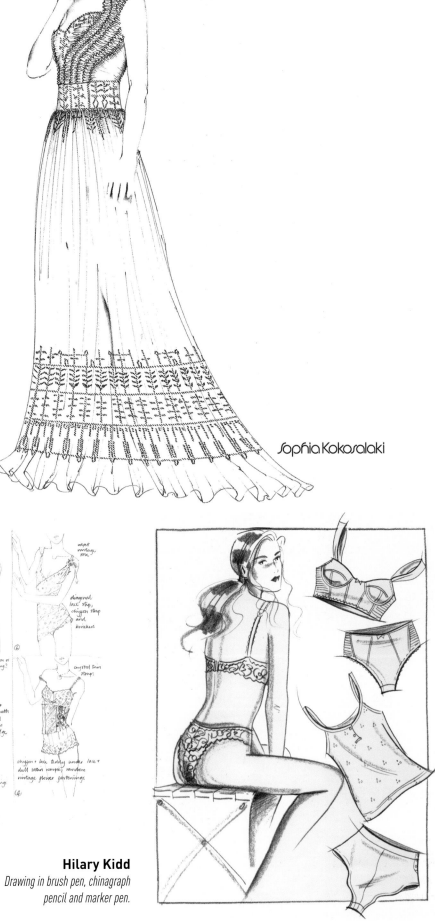

Sophia Kokosalaki

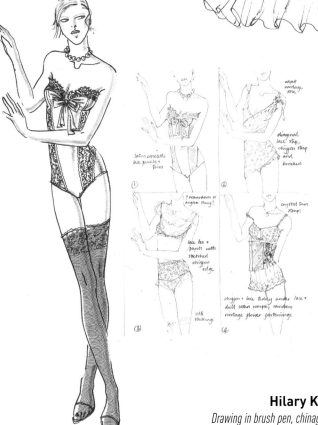

Hilary Kidd
*Drawing in brush pen, chinagraph
pencil and marker pen.*

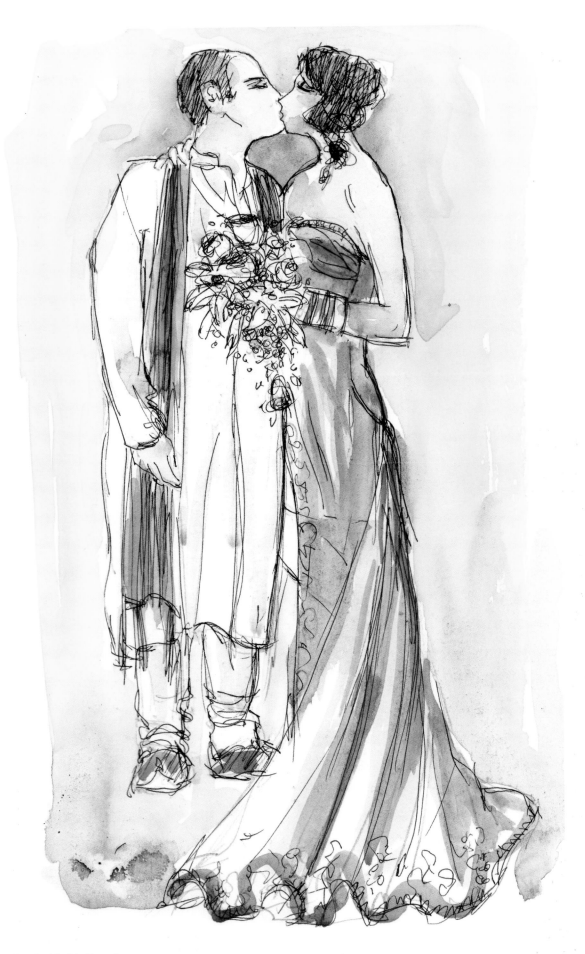

Rosie McClelland
'Wedding', 2011
Pen and watercolour illustration.

Paul Wearing
Client: *Neiman Marcus – The Book*
Digitally produced illustration.

Patrick Morgan
FACING PAGE
*Illustration using pen, ink and pencil
on 310 Somerset paper.*

Hormazd Narielwalla
Client: *Les Garçons de Glasgow*
*Illustration of street photographers
Daniel Stern and Jonathan Price –
November 2011
Digital collage of tailoring patterns,
vector illustration and photography.*

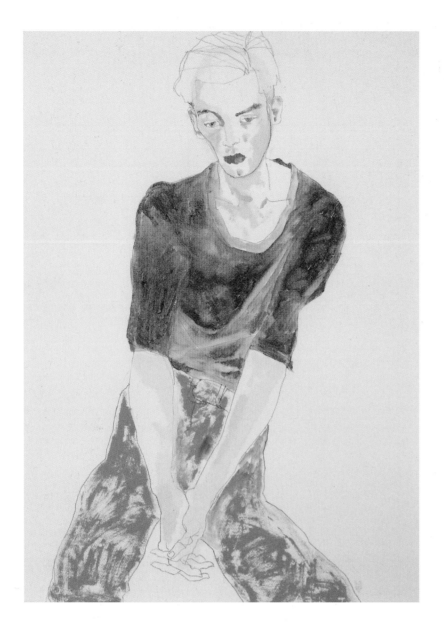

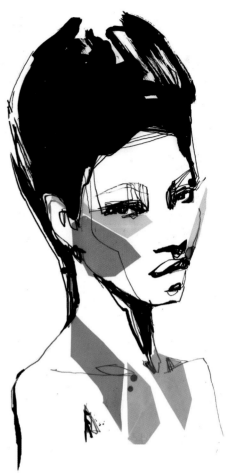

Stina Persson
*This illustration was created
using ink and cut paper.*

Howard Tangye
*'Jake', portrait 2011
Mixed media on paper.*

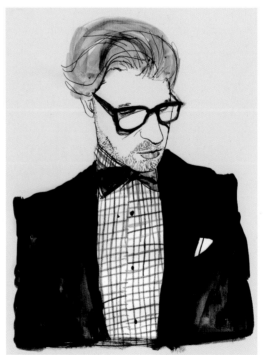

Patrick Morgan
*Drawn with pen and ink on 310 Somerset
paper. Brushes, crayons, pens, pencils,
rollers and stencils were used for mark-
making on block areas. Artwork scanned and
colour-managed in Adobe Photoshop.*

Patrick Morgan
FACING PAGE: *Drawn with pen
and ink on 310 Somerset paper.
Brushes, crayons, pens, pencils,
rollers and stencils were used
for mark-making on block areas.
Artwork scanned and colour-
managed in Adobe Photoshop.*

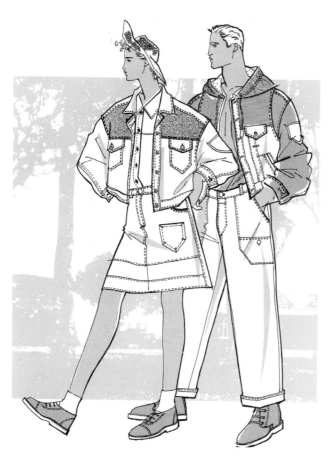

Billy Atkin
Client: *Design Intelligence, 1980s*
Drawn with fibre-tipped pen and Letratone.

Mary Edyvean
Client: *Deryck Healey International, 1978/9*
Drawn with fibre-tipped pen.

Stina Persson
Client: W Magazine –
Van Astyn bag – round-
up spread 2010
Pen and ink illustration.

Rosalyn Kennedy
Client: *Prism, 1981*
Illustrations of five figures using fibre-tipped pen.

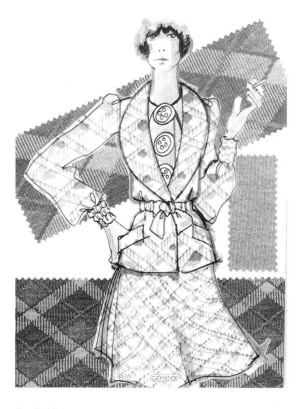
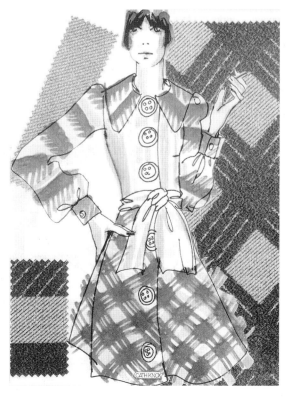

Cath Knox
Two illustrations using collaged fabric
swatches with a painted acetate overlay.

Hormazd Narielwalla
Client: *ATOPOS cvc, Athens, Greece*
Touring exhibition RRRIPP Paper Fashion May 2011
Illustration of the fashion icon Diane Pernet, created with
paper collage, vector illustration, tailoring patterns and
reproductions of paper dresses from the ATOPOS archive.

Howard Tangye
FACING PAGE: *'Arthur', circa 2004*
Mixed media on card.

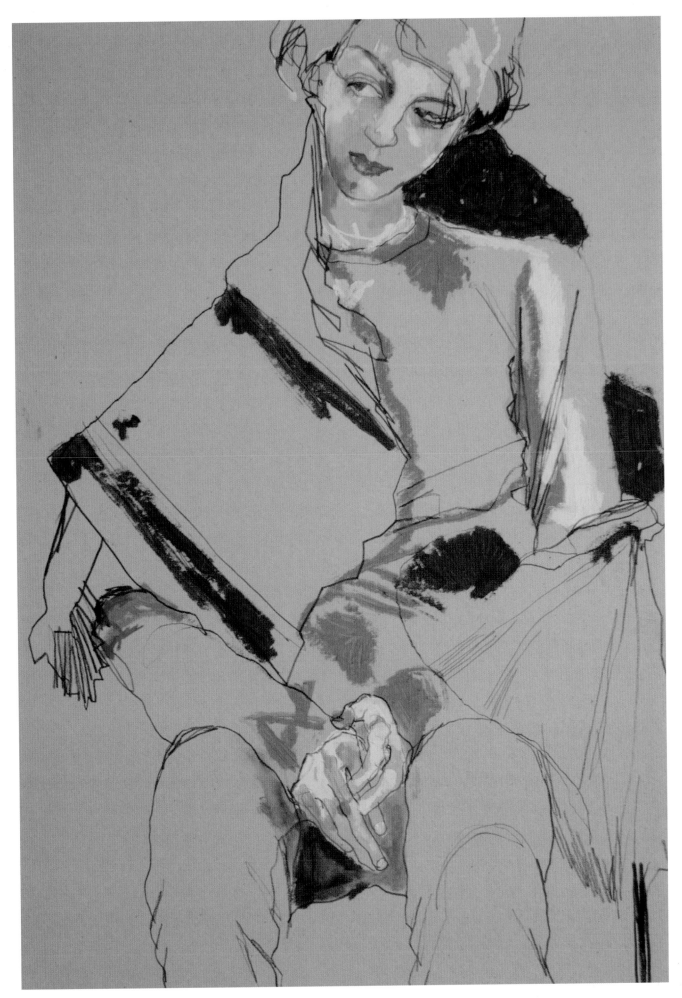

CONTRIBUTORS

The American Intercontinental University
www.aiuniv.edu

The University of Brighton
Yvonne Deacon – Senior Lecturer in visual research for fashion and textiles.
www.brighton.ac.uk

Central Saint Martins
Howard Tangye – Senior Lecturer Womenswear
www.csm.arts.ac.uk

Charlie Allen
www.charlieallen.co.uk

Ian Batten
ianbatten2002@yahoo.com

Pik Yee Berwick
berwick1@nyc.rr.com

Noel Chapman
nbassociates@btinternet.com

Judith Cheek
judith.cheek@btinternet.com

The Cloth Shop
www.theclothshop.net
Tel. 0208 968 6001

Lynnette Cook
coookbook@yahoo.co.uk

Yvonne Deacon
yvonnedeacon@googlemail.com

Mary Edyvean
mary.wilson2010@hotmail.co.uk

Mariella Ertl
mariellaertl@gmx.de

Martina Farrow
AGENT: NEW DIVISION
www.newdivision.com
www.martinafarrow.com

Claire Fletcher
www.clairefletcherart.co.uk

Henrietta Goodden
henri@post.com

Neil Greer
neiltendenz@aol.com

Katharina Gulde
www.katharinagulde.com

Clare Dudley Hart
clarehart@btinternet.com

Lesley Hurst
lesley.hurst@virgin.net

Rosalyn Kennedy
rosalynkennedey@hotmail.com

Hilary Kidd
www.hilarykidd.co.uk

Sophia Kokosalaki
www.sophiakokosalaki.com

Rosie McClelland
www.rosiemcclelland.co.uk

Patrick Morgan
www.patrickmorgan.co.uk

Hormazd Narielwalla
www.narielwalla.com

Stina Persson
AGENT: CWC-i www.cwc-i.com
www.stinapersson.com

Bruce Robbins
bdrobbins@btinternet.com

Mitchell Sams
m@mitchellsams.com

Anthea Simms
www.antheasimms.com

Howard Tangye
www.howardtangye.com

Textile View Magazine
www.view-publications.com

Anne-Marie Ward
Workspace photograph, page 8

Paul Wearing
www.paulwearing.co.uk

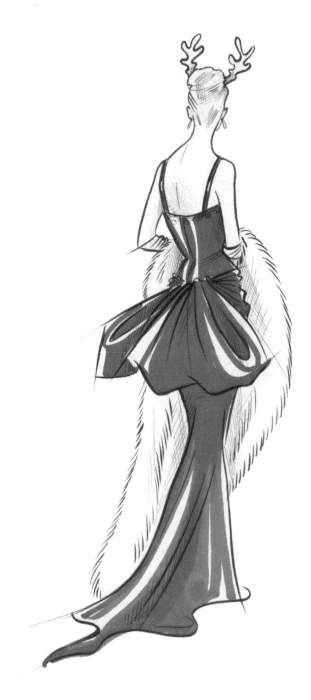

Hilary Kidd
Brush and marker pen.